John Hedgecoe

Photographing people

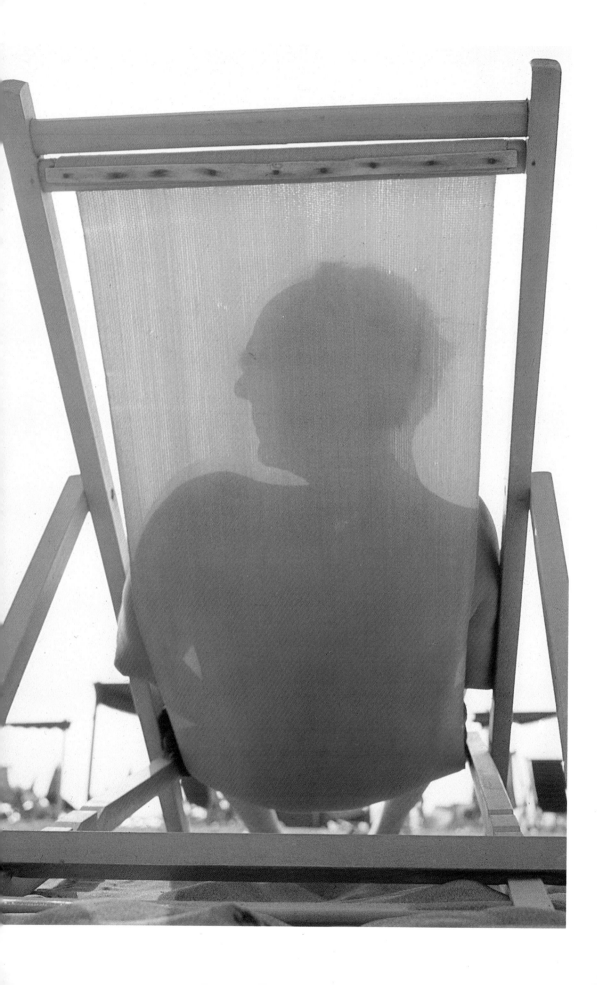

John
Hedgecoe

Photographing
people

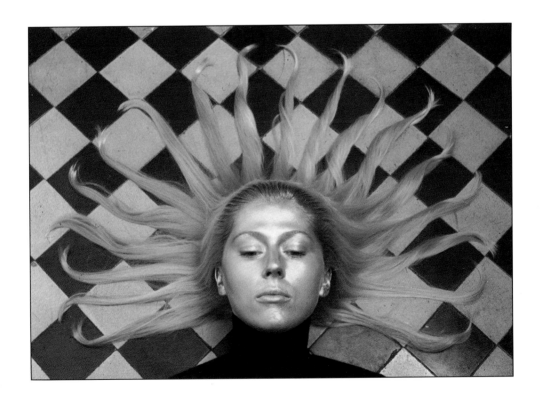

COLLINS & BROWN

First published in Great Britain in 2000 by
Collins & Brown Limited
London House
Great Eastern Wharf
Parkgate Road
London SW11 4NQ

Distributed in the United States and Canada by
Sterling Publishing Co, 387 Park Avenue South,
New York, NY 10016, USA

ISBN 1 85585 763 4 (pb)

Reproduction by Colour Symphony Pte Ltd, Singapore
Printed and bound by Toppan Printing Co Ltd, Hong Kong

CONTENTS

INTRODUCTION

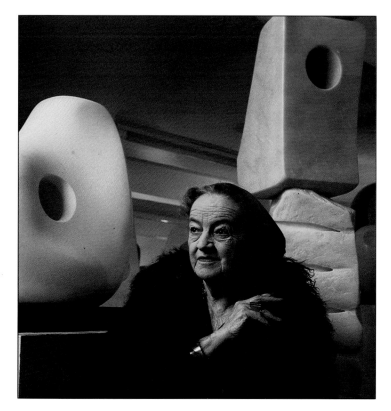

◀ Lighting and framing
Much in portrait photography depends on a careful lighting scheme and framing that adds to our understanding of the subject. Here I posed the sculptress Barbara Hepworth between two of her works and lit her with daylight-balanced flash, recording the tungsten-lit room in the background as bright orange.
80mm, 1/60sec, f/16

▶ Backgrounds
For this study of the painter Francis Bacon, the most appropriate and easiest background to use was his canvasses, propped against a studio wall. I then used the studio daylight.
28 mm, 1/125sec, f/8

Most of us consider taking pictures of people, which is all that portraiture is, to be one of the main reasons for owning a camera. This book aims to show you how even simple studies of family or friends can have wider appeal, and to encourage you to broaden your approach to this fascinating subject.

This book is not meant to be a technical guide to cameras – most of what is discussed and illustrated can be emulated with whatever photographic gear you possess, whether it is high- or low-tech. Instead, the book is designed to provide inspiration – showing a wide variety of ways in which portraits can be taken.

The first chapter shows some of the main techniques and styles that can be used. Other chapters deal with aspects of photography in a wide range of situations, both in the home or studio and on location. Because lighting is central to successful portraiture, you will find diagrams explaining how I took particular photographs.

As your confidence grows, you may want to try a thematic approach. This requires greater commitment since subjects, such as people involved in specific occupation, can be difficult to gain access to. However, the results are very immediate and, as a record of events or activities, can give you and your subjects long-term pleasure.

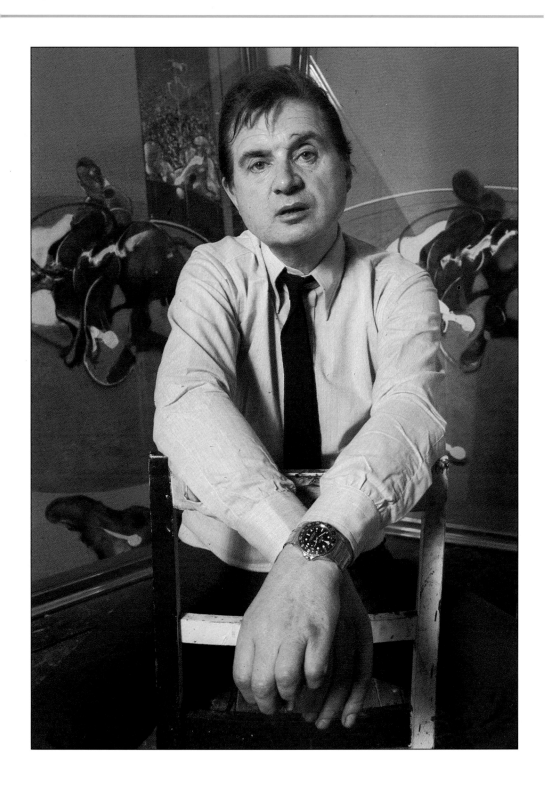

INTRODUCTION

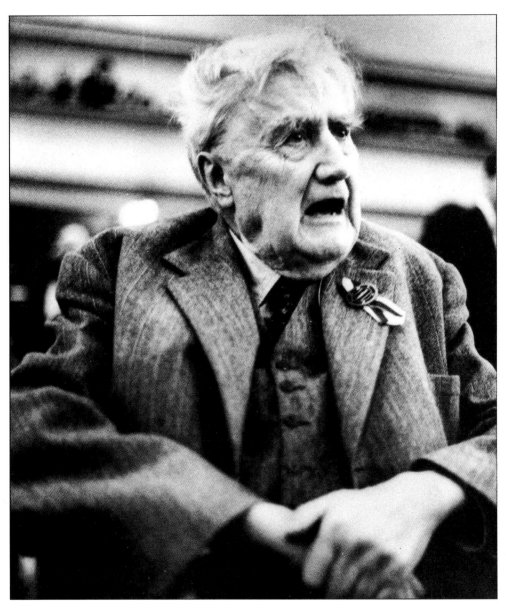

▲ Low-key approach
For a varied portfolio of portrait photographs, you must learn to adapt your style and approach to your subjects. This shot of the composer Ralph Vaughan Williams shows that his attention, and obvious concern, was concentrated on the performance of the orchestra. Even at rehearsals you will probably not be allowed to use flash because it is distracting, and even the camera shutter noise can disturb the music.
Ilford HP5, 1/60sec, f/5.6

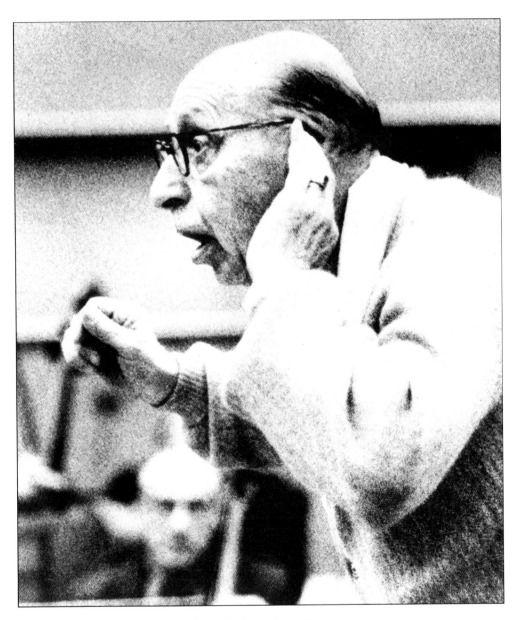

▲ Artist at work

Different temperaments produce different atmospheres, and it is this unpredictability that makes portrait photography such an engrossing subject. Here we see the Russian-born composer Igor Stravinsky conducting his orchestra during a rehearsal. This is an image of a more controlled personality, compared with that of Vaughan Williams opposite, and shows someone who is totally immersed in his music. 50mm, 1/30sec, f/8

INTRODUCTION

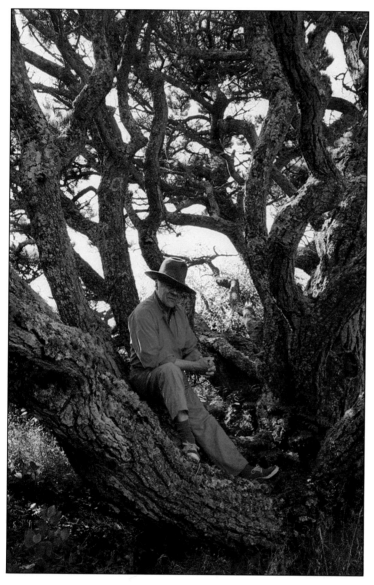

▶ **Mimicking daylight**
When using flash photography, the best approach is generally to adopt a lighting set-up that gives the impression of natural light. For this study, I set up a portable studio light with a large 'soft box' diffuser to create lighting that appears like diffused sunlight coming through a nearby window.
80mm, 1/60sec, f/8

▲ **Natural light and shadow**
This picture of artist Patrick Heron suggests a flamboyant personality, dressed as he is in contrasting blue, red and purple clothes. My intention was to create a balanced composition by posing him surrounded by the highly textured surfaces but subdued colour of an imposing, ancient tree. The result of this approach is to give emphasis to his brightly coloured clothes.
85mm, 1/125sec, f/11

INTRODUCTION

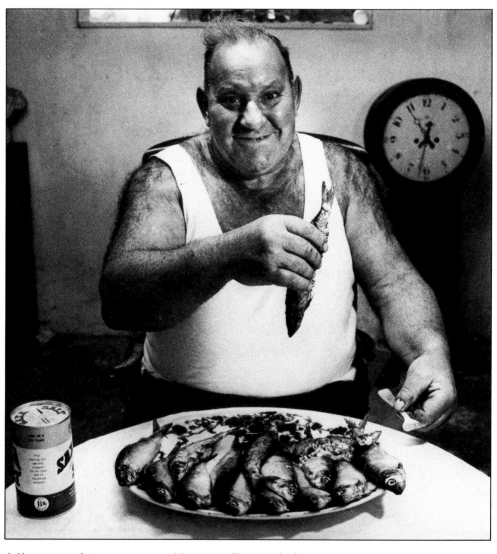

▲ Hearty appetite

One of the abilities of a successful portrait photographer is a desire to get on with many different types of people and to find common points of interest. These develop from the rapport that you need to build with your subjects. It is an easy mistake to think that all your portraits need to look 'natural' and appear unaffected by the presence of the camera. The strength of this picture lies in the fact that the gourmand was playing to the camera and to me as photographer. The unconcealed glee with which he is about to tackle an enormous plate of freshly-grilled fish, makes him a very appealing character. 80mm, 1/60sec, f/8

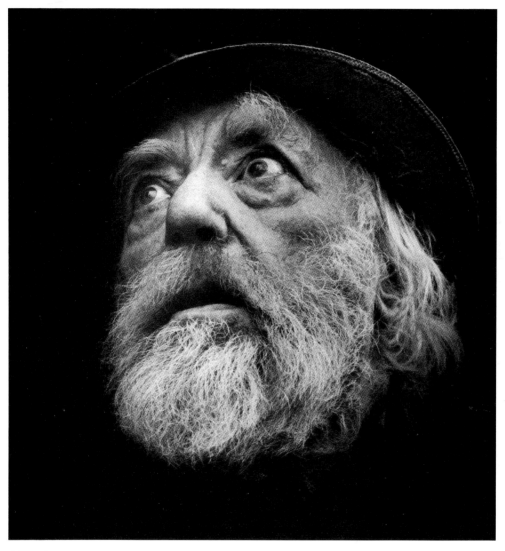

▲ Tonal contrast
Dramatic lighting such as this has great impact, gives your work a very professional look, and is extremely easy to achieve. I caught the painter Augustus John looking rather furtive, almost like a villain in some silent melodrama. The lighting was achieved by using a shaft of daylight from a nearby door, and by exposing for the highlight on his face; the surrounding area in diffused light recorded as deep shadow. A low camera angle helped to increase his apparent stature, and this also adds to the strength of the photograph.
120mm, 1/125sec, f/11

INTRODUCTION

▶ **Composing in colour**

Simple blocks of strong colour, mainly blue, yellow and white, make a bold statement in this unusual portrait, where the subject's head is obscured by an umbrella. Although frequent advice is given about avoiding the high midday sun for pictures because it produces unflattering shadows, it can be ideal for intensifying colour, an effect that I enhanced by the addition of a polarizing filter to the camera lens.
60mm, 1/250sec, f/16

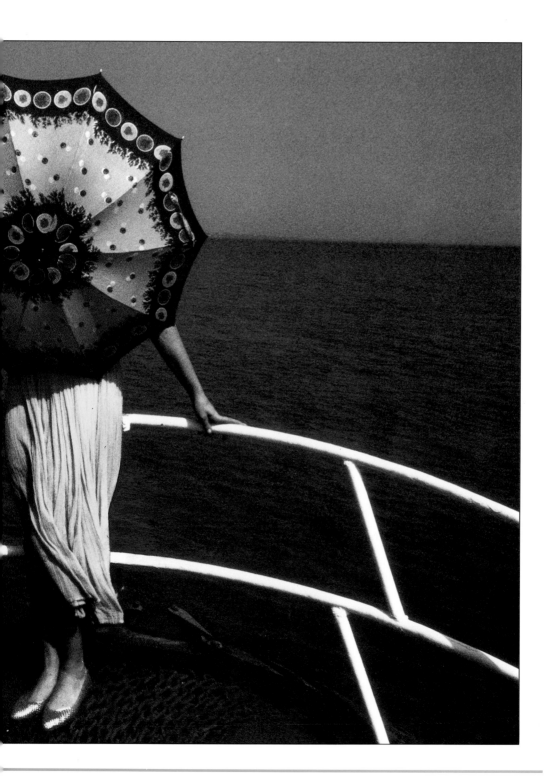

THE BASICS OF PORTRAITURE

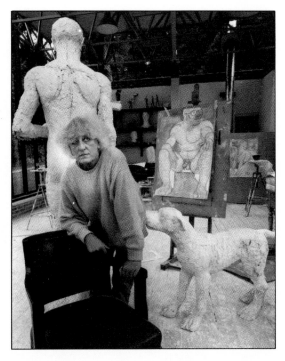

50mm,1/60sec, f/11

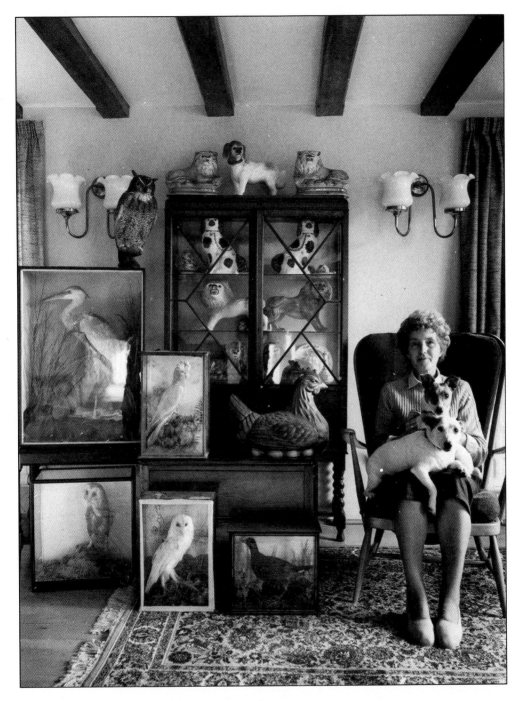

80mm, 1/125sec, f/11

TYPES OF APPROACH

There is no one correct approach to portrait photography: much depends on the subject, the way that person wants to be portrayed, and the artistic decisions you need to make as photographer. Bear in mind though that the style of the portrait, either formal or informal, studio or location, should always be appropriate.

STUDIO OR LOCATION

In general, it is fair to say that using a studio with a non-professional model brings an air of formality. In unfamiliar surroundings most people tend to freeze up, and it is therefore the photographer's job to get them to relax.

Moving the camera into a person's home or place of work immediately brings about a change in the type of picture produced. Not only will they tend to be more relaxed, you will have the chance to display something of your subject's personality and interests, expressed through his or her possessions and surroundings.

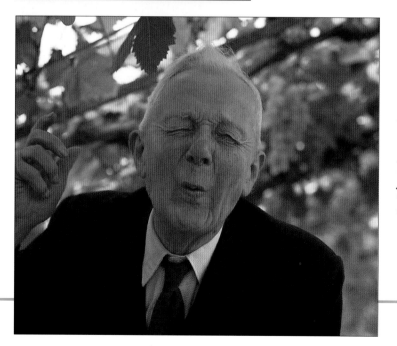

◀▼ Comic relief
*Portraits can be switched from being formal to informal in style in a split-second, just by the pose adopted by the sitter. However, to do this the subject needs to be relaxed, and this is much easier if they are on home ground. In the shot on the left, the posed expression predominates and therefore the picture looks serious. With a gesture of the hand, and a pulled face (below), the character of the shot is completely transformed.
85mm, 1/125sec, f/4*

▶ Artist in residence
*Portraits are often more revealing when taken on the subject's home ground. Here, the most appropriate background for artist John Bellany was one of his canvasses.
80mm, 1/60sec, f/4*

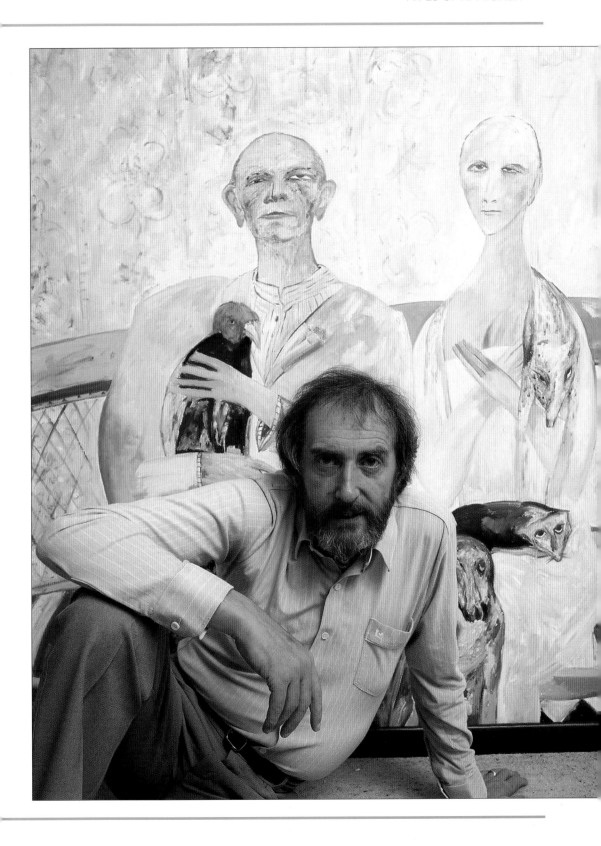

MOOD AND EXPRESSION

One of the main reasons people become interested in portrait photography, apart from the recording of family and friends, is that the human face is such a changeable and expressive indicator of feelings and moods. It really can be very rewarding to come away from a portrait session knowing that in your camera, just waiting to be developed, is a set of photographs that really provides an insight into the character of the person you have been working with.

To achieve this end, however, requires that you, as photographer, strike up a rapport with your sitter. This is even more important when shooting in the studio, where it is likely your sitter will feel ill at ease. But even when working on location, you must engineer the situation so that the person reacts to you – in other words, starts to express his or her mood through facial expressions and general body language. To capture this successfully, however, means that you need to use the changeable and fleeting quality of light as your ally.

THE MOODS OF NATURAL LIGHT

Although what we describe as natural light is illumination from a single source – the sun – it is capable of producing an extremely diverse range of effects. Even during the course of a single day, lighting quality can vary from the soft, diffused light of a mist-shrouded morning to the harsh, yet detail-revealing, light of midday, when the sun is more directly overhead.

Most portrait photographers rely on natural light for their pictures. An exercise that anybody can try involves nothing more than taking a series of photographs of the same model, framed in much the same way, but under different lighting conditions. Start early in the morning and carry on through to late afternoon so that you can more fully understand the variability of sunlight.

▲ **Highlighting the face**
For this outdoor portrait of the artist Duncan Grant, I used diffused fill-in flash and a wide aperture in order to bring the face out of gloomy overcast light. 50mm, x-sync, f/5.6

◀ ▲ Relaxation
You can see from these pictures how mood and expression can vary. By building up a rapport, the girl lost all her initial shyness and

is having a thoroughly enjoyable time.
85mm, 1/125 sec, f/4

MOOD AND EXPRESSION

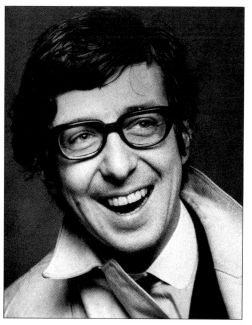

◄ A relaxed attitude
I had to set the lights carefully for this picture. My subject had basically a very relaxed attitude and an easy smile, which helped. By tilting the angle of the glasses correctly I avoided any reflections that would have obscured his eyes. 85mm, 1/60sec, f/8

► Candid approach
With this lovely lady I was spoilt for choice when it came to facial expressions. She was in the middle of an animated conversation with a few of her friends when I took this shot. 85mm, 1/30sec, f/2.8

▼ Artist at work
The natural light in Graham Sutherland's studio was perfect for photography. The artist felt completely at ease there, surrounded by his canvasses and other familiar possessions. Generating this relaxed atmosphere can be the hardest part of portrait photography. 50mm, 1/125sec, f/5.6

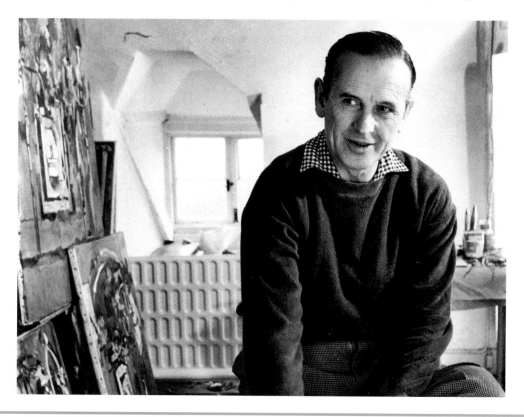

REVEALING CHARACTER

One of the most difficult tasks in portrait photography is trying to reveal the character and personality of your model or subject. First, you have to overcome the natural inhibition most people feel in front of the camera. Second, and more importantly, you need to strike up a rapport with them, so much depends on your approach.

There is also much scope here for candid portraiture. Camera shyness will not be a problem if people are unaware of the camera. Even in the studio, though, given enough time to grow accustomed to the surroundings, most people will relax and start to behave normally.

It is not possible to lay down rules about how you should play your part as photographer – it will change from session to session. Some people will remain wooden unless cajoled and directed, while others will freeze up if treated that way.

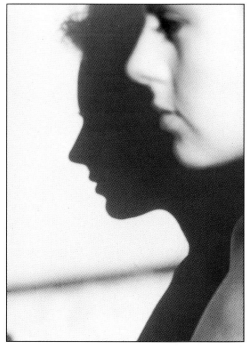

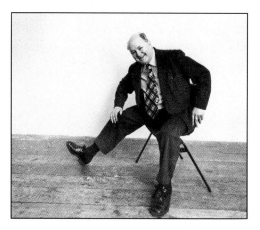

◄ Rounded personality
My subject was very nervous, so I swapped from a telephoto to a moderate wide-angle in order to establish closer contact. Through constant talking, joking, and coaxing, I finally won him over.
35mm, 1/60sec, f/4

▲ Candid approach
Using a long lens during a break in shooting, I carefully focused on the model's shadow, and the resulting picture gives a soft image with a hard outline.
135mm, 1/60sec, f/2.8

◄ Simple silhouette
When photographing children, results are nearly always better if you keep it simple. For this shot, a wooden rocking horse resulted in a natural study of children at play.
85mm, 1/125sec, f/8

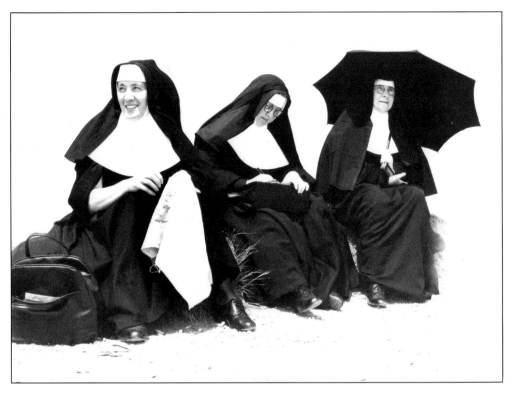

▲ Chance happenings
It was one of those unrepeatable scenes, coming across these three nuns sitting on a beach on a hot day by the coast. Each one was engrossed in her own activities, yet seemed part of a perfectly unified group.
85mm, 1/250sec, f/8

▶ Studied pose
People can express their personality through all manner of things. Here, clothes, hair and expression all combine to show the concentration of the guitarist.
80mm, 1/60sec, f/2.8

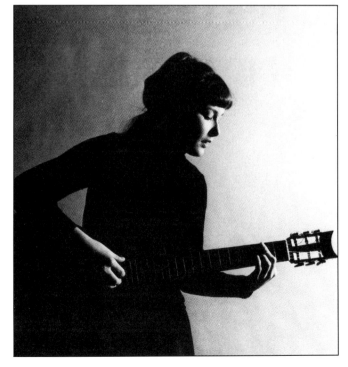

CANDID PORTRAITS

The secret of successful portrait photography lies in being properly equipped and well-prepared – and this is especially true for candid portrait photography.

It is vital that you know your equipment thoroughly before setting out. Time spent fumbling with camera controls and lens settings means lost opportunities. Ideally, set your lens to about f/8 or smaller (unless this results in impossibly slow shutter speeds) and prefocus on where you expect your subject to be. Compacts, because of their unobtrusive size, level of automation, and quiet operation, can seem to have an edge over SLRs. But the SLR's choice of lens and control of aperture and focus usually mean that it produces better results.

DECIDING ON LENSES

With SLRs, 35mm and medium-format, you need to make a decision about which lens to use. For candid shots of strangers, a long lens will give you that distance you need so as not to intrude. Conversely, using a wide-angle lens produces an intimate closeness that gives the impression that you are among the crowd. Wide-angle lenses also produce an extensive depth of field at all apertures, making focusing less critical. Beware, however, of possible edge distortion with extreme wide-angle lenses.

DIFFERENT APPROACHES

Most people, when they think about candid photographs, assume that what is meant is taking pictures without the subject being aware of it. This is certainly one approach, but it is not the only one.

Another way is to take candids by arrangement: make an appointment to visit a location, which could be a school, shop, playgroup, or artist's studio, in order to record the activity there. You will find that, very soon, your subjects will forget about you being there and just get on with their normal behaviour.

Flash will usually be inappropriate in candid situations, since it creates its own, artificial, environment and highlights your activity. Instead, take plenty of fast film.

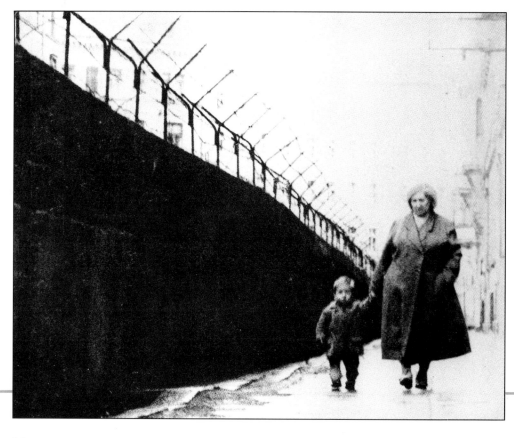

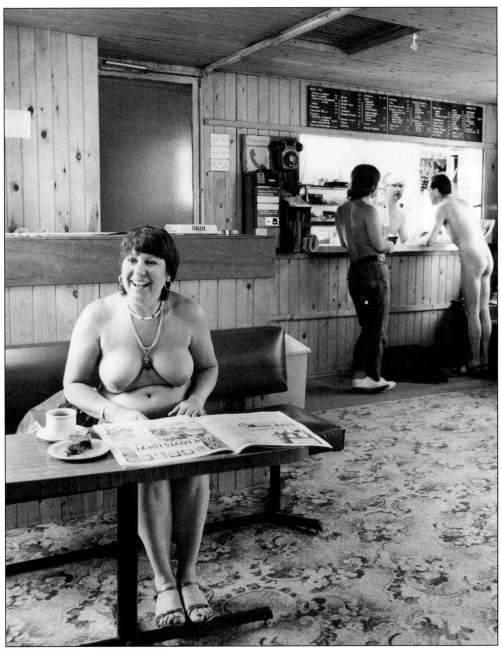

◄ Likely background
With such an emotive symbol as the Berlin Wall as a background, I just waited for a person to walk by to give the picture atmosphere as *well as scale. Berliners were well used to photographers at the Wall, and did not really react any more.*
80mm, 1/60sec, f/8

▲ Nudist camp
Visiting an informal nudist camp reception area provided a relaxed, informal atmosphere where nobody cared how you were dressed. *Daylight was strong enough for a small aperture to be used, so I prefocused the lens and took a quick snap.*
125mm, 1/60sec, f/8

CANDID PORTRAITS

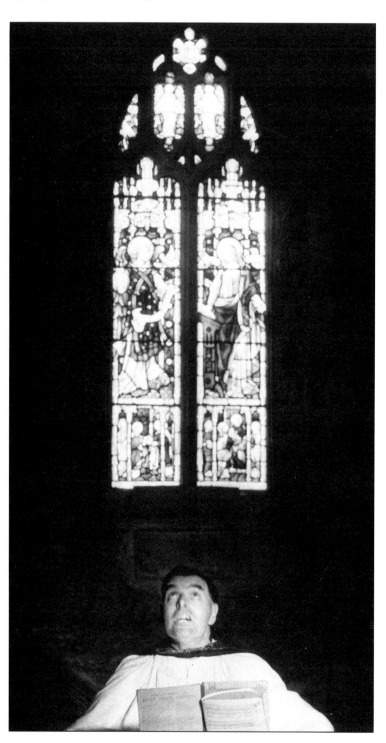

◀ **Capturing the spirit**
Although cameras are not normally allowed during church services, modern compacts are so small and quiet that they do not intrude. The only light I had for this candid portrait was that streaming through the stained-glass window behind. But it was enough to capture this chorister in full voice. I exposed for the face, and a shutter speed 1/30sec resulted in some subject movement.
35mm, 1/30sec, f/3.6

▶ **Music and dance school**
Rehearsals at the local music and dance school provided me with a good opportunity for candid pictures. Because I was working indoors, and using existing window light only, I used ISO 400 film. Even so, most of the time I found I had to use my standard and wide-angle lenses wide open at apertures of between f/2 and f/1.4. Flash would have destroyed the atmosphere.
50mm, 1/60sec, f/2

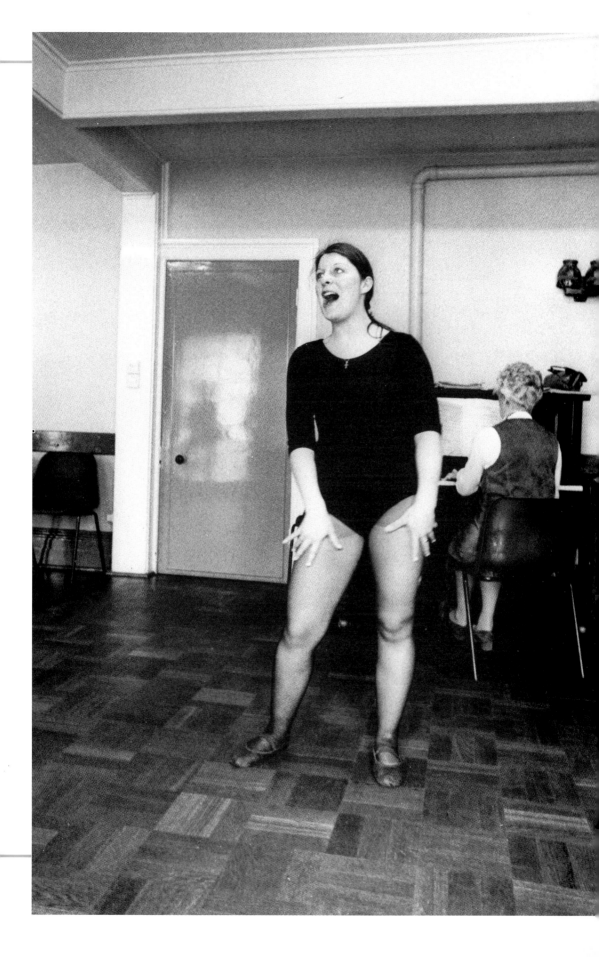

FRAMING HEADS

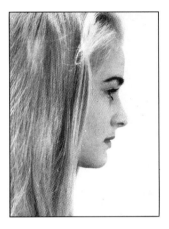

▲ Tonal range
When the tonal range of your picture is limited, as in the profile here, you need to ensure that sufficient difference exists to separate your subject from the background. The effect is high key and appealing but needs handling with sensitivity.
85mm, 1/125sec, f/2.8

In the same way as framing the whole figure is vital to the balance and flow of the composition so, too, is the position of the subject's head within the frame when you are taking a head-only or head-and-shoulders portrait. It is important to remember that head shots need not fill all the available space – positioning your subject in an unexpected and small part of a larger scene can add immeasurably to the impact of the shot.

Nearly all portraits are taken from approximately the same height, with the camera supported at head height. As a result, pictures all have much the same character to them. Next time you are conducting a portrait session, purposely take at least some of the pictures with the subject obviously off-set in the frame. This in itself will not be sufficient to generate interest, so ensure that the rest of the frame contains elements that add to the composition. If you use a rigid camera case, stand on it to gain height or find an alternative platform such as a wall to stand on. You can also simply squat down and shoot upward, especially if this brings a worthwhile background into shot.

▼ Central framing
A basic centrally framed head-and-shoulders shot can be made more interesting by asking the subject to incline his or her head (or by angling the camera). This introduces a little additional tension to the composition. Making use of the picture diagonal is also a worthwhile innovation.
35mm, 1/60sec, f/4

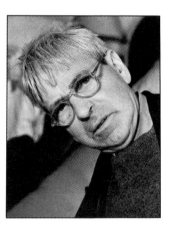

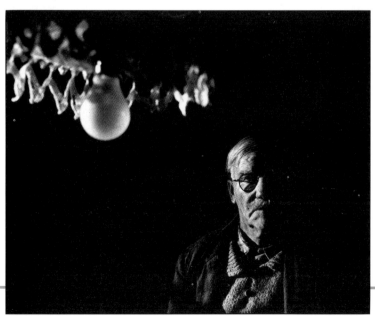

◄ Low-key effect
For this head-and-shoulders shot I wanted to introduce a puzzle by implying that the unlit light bulb in the foreground was somehow responsible for the light falling on the man's face. To bring the bulb into shot I had to crouch on a chair and use an aperture that just gave enough depth of field. The actual light was daylight from the left.
80mm, 1/30sec, f/5.6

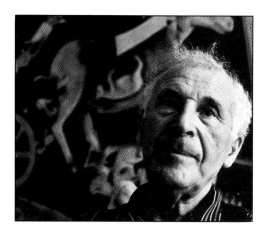

◀ Off-centre framing
In this picture, the off-centre placement of the painter Marc Chagall needed careful lighting. In order to include his painting, I used the maximum depth of field possible. The natural light gave a better atmosphere and the highlight balances a much larger shadow area.
120mm, 1/30 sec, f/11

▼ Lowering the horizon
One of the advantages of experimenting with different framing, either high or low, is the changing effect it has on the horizon line. For the picture of Henry Moore, I stood on my camera case and shot down at him, and so included the skeletal forms of an avenue of winter trees.
50mm, 1/60 sec, f/11

▲ Diagonal line
This shot of the poet Ted Hughes gains impact through the tight cropping at the chin and the placement of the head on the frame diagonal. The composition has been strengthened by shooting from an exaggeratedly low camera angle close in to the subject.
35mm, 1/125 sec, f/4

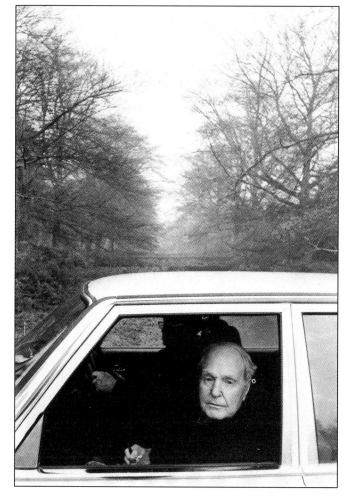

VIEWPOINTS

By seeking a variety of viewpoints it is possible to capture all manner of apparent changes in the appearance of your subjects. Photographers have a tendency to use their cameras at one height. With the eye-level viewfinder found on SLRs, they shoot from around five feet above the ground. With the waist-level finder found on some medium-format cameras, they shoot from just over three feet. Very few make the conscious effort to utilize the potential for visually more exciting images by simply lying on the ground, kneeling, or climbing up any convenient object.

Changing camera height not only adds variety to your pictures, it can alter the meaning of them. You increase the apparent stature of a person, for instance, by lowering the position of the camera; not only does this make him or her appear taller, but you imply that that person has authority because the camera is being looked down on.

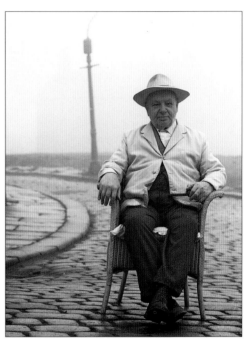

▲ Appropriate setting
A slightly low viewpoint for this portrait makes the figure a strong shape in relation to the cobbled road. Percy Shaw, the millionaire inventor of road markers known as cats' eyes, did not change his simple way of life because of the fortune his product brought him, and this is what I tried to convey. 80mm, 1/125sec, f/11

◄ Viewpoint and shape
I chose a ground-level viewpoint to isolate the farmer and his dog against a neutral-toned sky and to emphasize the triangular composition formed by his splayed-out legs. This concentrates attention, as does the farmer's gaze, on the hands peeling potatoes. 28mm, 1/250sec, f/5.6

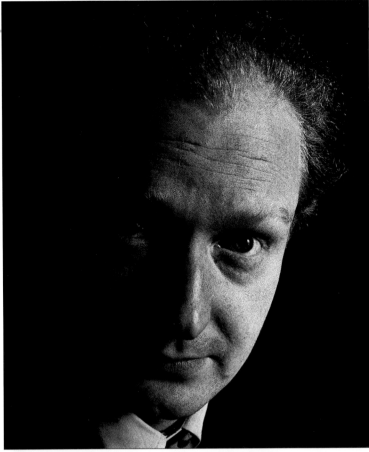

◄ **Reinforcing the effect**
In this shot, an elevated camera position has made the subject's head appear slightly larger than it would have otherwise have done. The tilt of the head has been reinforced by the position of the floodlight to the right of the face.
135mm, 1/60sec, f/4

▼ **Using the stairs**
A spiral staircase makes an excellent setting for investigating the effects of different viewpoints. As well as providing an interesting setting, with sweeping curves, sharp angles and areas of high-light and shadow, you can use the stairs to gain height and look down on your subject.
50mm, 1/30sec, f/8

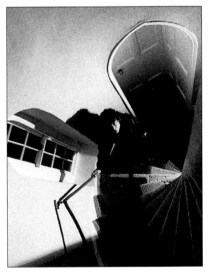

▲ **Problem-solving with camera height**
Framing this portrait at eye level, the strong sunlit line at the top of the rocks immediately behind the subject seemed to be passing *through his ears. By kneeling down, this line was lowered in the shot, and a more uniformly dark back-ground was provided for the head.*
80mm, 1/125sec, f/11

USING SHAPE

Just as individual colours and colour combinations can subtly determine our feelings about certain scenes, so too can shape influence our reactions. Undulating, rounded, or flowing shapes imply calmness, while jagged, sharp or irregular shapes almost always set up tension in a picture.

CONTROLLING THE EFFECT

Shapes of all sorts occur naturally as part of practically any scene in which you might choose to pose your subjects. On location it is a matter of using the camera selectively, framing the shot so as to include some shapes while excluding others. But if you are working at home or in a studio, you can decide how to dress the set in order to create a particular mood.

Shapes in scenes can also be controlled by your choice of lens and camera angle. As with all types of photography, if time and circumstances permit, it is always worthwhile to move round your subject, looking through the camera viewfinder to see how your impressions of the scene change. Take advantage of the terrain or the nature of the room in order to gain height and look down on your subject, or lie flat and look upwards.

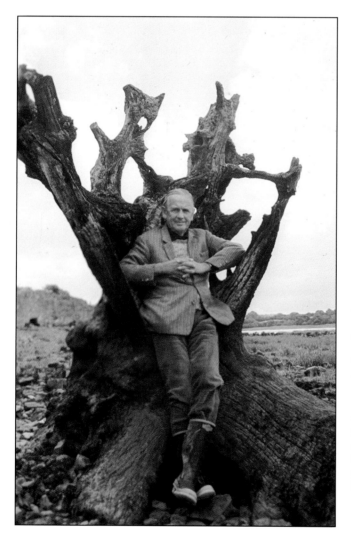

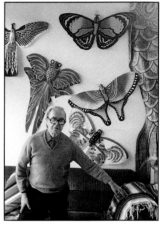

▲ **Arranged shapes**
The strong shapes and colours of the kites on the wall challenge the dominance of the subject, Michael Rothenstein, who was positioned so that his body did not obscure them. I took this shot with a fast, ISO 1000, print film so that I could make do with the ambient light. 28mm, 1/60sec, f/4

◄ **Natural shapes**
The gnarled and twisted shape of a dead tree trunk takes on the appearance of a giant hand cradling the subject. 85mm, 1/125sec, f/8

▲ Subject as shape
Here I used a low camera angle and a wide-angle lens pointed sharply upward in order to make my subject, Barbara Hepworth, seem almost larger than life.
60mm, 1/60sec, f/5.6

Using wide-angle lenses has the effect of increasing the apparent distance between shapes. Used from a low viewpoint, wide-angle lenses can be used to create a dominant, tapering image.

Telephoto lenses, on the other hand, tend to compress shapes as they are used further away from the subject. This property can be used to underline strong relationships between forms.

Shape, of course, is not only a feature of the environment, whether natural or man-made. Your subjects themselves can be posed to form interesting shapes.

CLOSE-UPS

There are both advantages and disadvantages to taking close-up portraits. On the plus side, you do not usually require complicated lighting schemes. Furthermore, unwanted backgrounds, or other potentially distracting elements in the scene, are excluded simply by standing closer to the subject, or by using a longer focal length.

On the negative side, you lose many of the variations afforded you by framing your subject in different ways. The closer in you move, the more important become the edges of the frame created by the image format.

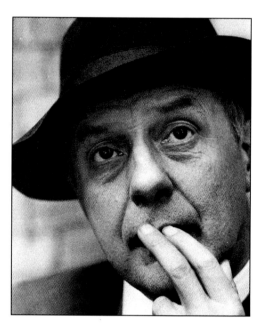

▶ **Lost in thought**
This photograph of the English poet and former Poet Laureate, John Betjeman, has caught him in a very relaxed and pensive mood. He has been perfectly framed by his hat and hands, both of which help concentrate attention on his face and his eyes in particular. Light was provided by overcast daylight through a window directly in front of him. 85mm, 1/60sec, f/4

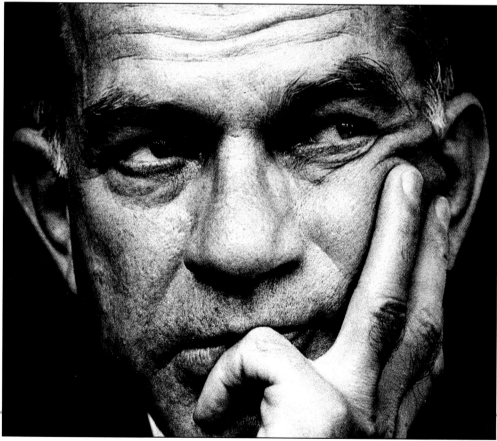

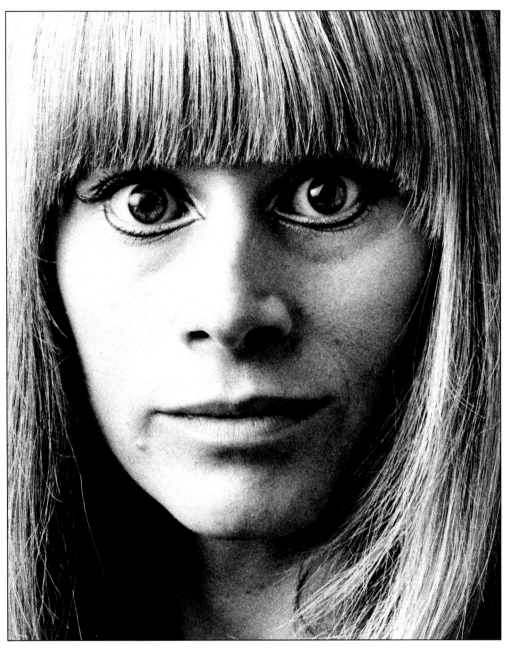

◄ High-contrast light
For this portrait of US Senator Fulbright, I wanted to show the strength of character of this often outspoken politician. The best type of lighting seemed to be off-camera flash. I used this undiffused in order to create a more stark, contrasty and powerful photograph.
120mm, 1/250sec, f/5.6

▲ Hair as frame
Close-ups of faces that exclude the background totally need particular care. In this picture the actress Rita Tushingham's large, saucer-like eyes seem to draw you into the picture. This is neatly framed by cropping in such a way as to leave her long hair and heavy fringe as the borders.
135mm, 1/60sec, f/5.6

CLOSE-UPS

▲ Full profile
When shooting a portrait in profile, it is important to leave sufficient space in front of the face to prevent the picture feeling cramped. In the movie industry, this space is known as 'looking room'. A small aperture and a telephoto lens were used to ensure that the background did not intrude.
135mm, 1/60sec, f/2.8

With framing as tight as this, wide-angle lenses would produce unacceptably distorted images, and a standard lens will not focus sufficiently close to fill the image area completely with just the face. In effect, this leaves the telephoto lens and, in order to avoid compressing the facial features to an unacceptable degree, you should, ideally, use a lens of about 85–135 mm, or a zoom including these focal lengths (such as a 70–200mm).

SELF FRAMING
With so little of the environment to work with, it becomes increasingly important to use the only ingredient at your disposal as a framing device: the subject. Notice in two of the photographs on the previous spread how hands have been used as part of the frame of the face, creating strong lines that lead the eye into the picture. Hats, too, make effective frames. In the third shot on the previous page, an almost perfect frame has been provided by the subject's hair. The effect is indeed powerful.

The pictures shown on these two pages are different in that they rely more on the format edges to confine the face. Cropping in too tightly, however, can appear uncomfortable.

▶ Flash fill-in
In this picture, the background is lit by natural daylight and the face by camera-mounted flash. The result is a portrait with great impact.
85mm, x-sync, f/4

▼ All-round lighting
The natural lighting for this portrait of historian A. P. Herbert was achieved by asking him to pose in his glass conservatory.
85mm, 1/250sec, f/4

◀ Background detail
Close-ups do not have to exclude the setting completely. Often, just a hint of background detail helps to throw your subject into sharper relief.
135mm, 1/250sec, f/4

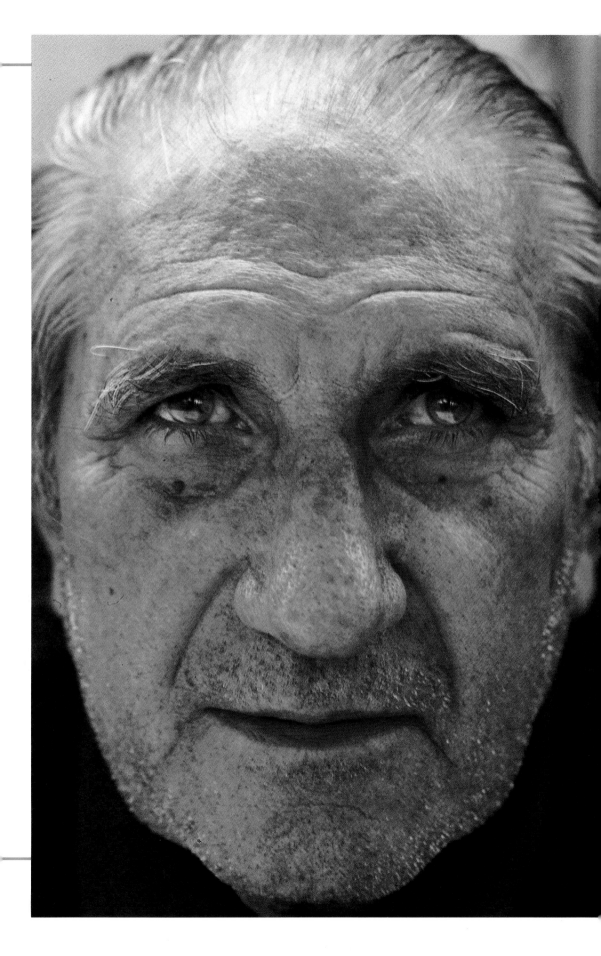

IN THE
STUDIO

80mm, 1/125sec, f/16

80mm, 1/125sec, f/5.6

THE STUDIO

It does not matter how well equipped your studio is if the type of pictures you can take is restricted for lack of space. When shooting portraits, for example, you should be able to place enough distance between the camera and the subject to take a full-length portrait using a short telephoto of about 85mm. In practice, a studio should be at least 15 feet (4.5 metres) long.

A high ceiling, painted matt white, is also important, so that light can be bounced off it and fall, evenly diffused, on the subject without creating unwanted colour casts. Walls that are matt black or dark grey allow you the most complete lighting control, but for most purposes white will do. If there are windows, white opaque blinds are useful, giving you extra control and allowing the studio to be used for either daylight or artificial-light photography.

Many first-time buyers opt for tungsten photoflood bulbs. Their advantage is that the light is continuous. You can therefore

▼ **The studio set-up**
1 Medium-format camera
2 35mm camera
3 Large-format camera
4 Film backs, film
5 Studio flash
6 Flash power pack
7 Photospot
8 Umbrella diffuser
9 Snoot, scrims and light filters
10 Barn doors
11 Photoflood
12 Reflectors
13 Projection unit
14 Camera stand
15 Tripod
16 Make-up area
17 Light-tight blind
18 Equipment cupboard
19 Stand for paper backdrop
20 Lightbox

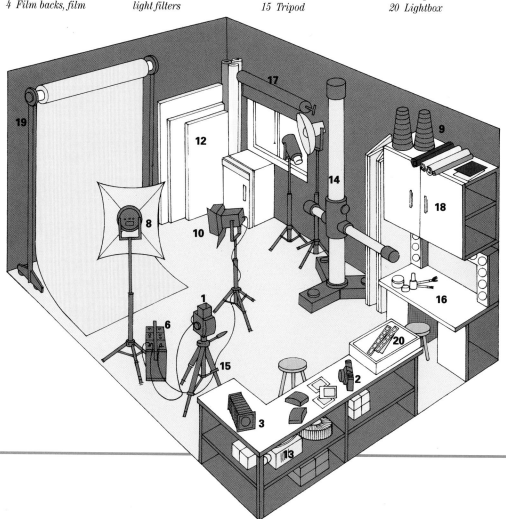

see how your lighting arrangements will look in the final picture. As you move the lights, shadows appear and disappear and you can make adjustments until you are satisfied. On the down side, tungsten lamps get hot, so are uncomfortable to be under for any length of time. When using colour film, you also need to correct for the orange tone of the lighting with blue filters or by using tungsten-balanced film.

Studio flash units work on the same principle as camera flash: a synchronization lead connects the shutter to the lights, which deliver an instantaneous burst of daylight-balanced light when the shutter is fully open. The lighting heads are supplied by a mains-powered unit, which allows variable flash output.

The greatest problem people have with flash is that it is difficult to predict the lighting effect. Good-quality flash heads, however, contain a low-power tungsten modelling light, which allows you to see the strength and direction of any shadows that will be created when the main flash heads fire. Also, medium-format cameras usually allow you to shoot Polaroid test prints, so you can see the effect of the lights, the composition and exposure before you shoot with the real film.

▼ Controlling the light beam
Whether using studio flash or tungsten light, you can still retain complete control over the strength and spread of light. Dish-shaped reflectors (1 and 4) are the most commonly used, with the deeper dishes giving the narrower beams. For a more concentrated beam of light, you can fit a snoot (2) to the front of your lighting unit. This attachment is ideal for lighting a very specific part of your subject or adding catchlights to the eyes. For a controlled beam of light, barn doors (3) are ideal. You can adjust the flaps independently for precise control of the light beam. For a general diffused lighting effect, direct your light into a reflective umbrella or 'brolly' (5).

▲ Slave unit
Slave units plug in via a standard jack plug to secondary flash units and trigger them in response to light emitted by the shutter-synchronized flash head.

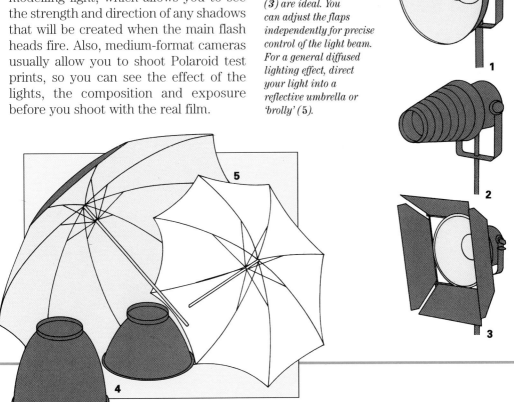

BASIC LIGHTING

You do not need a lot of equipment in order to produce professional-quality studio photographs. Basic space requirements to allow you sufficient distance from your model to use a portrait lens, and sufficient space behind and to the sides to permit different lighting set-ups, have already been discussed. For all the pictures on these two pages, you would only need a single studio light.

First of all, set up the background and connect lights to the power source. Place a chair or stool in the appropriate position. If possible, place the model 6–7 feet (2m) away from the background to give yourself room to light it separately.

Move each light in an arc, taking in the front and sides of your model, and monitor the results through the camera. Mark the position of each light when you are happy with the effect.

As you add new lights, or as the model alters pose or expression, you may have to alter the position of lights already set.

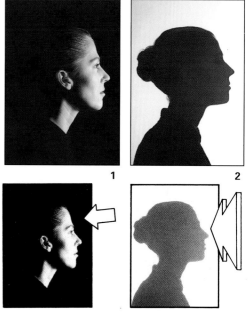

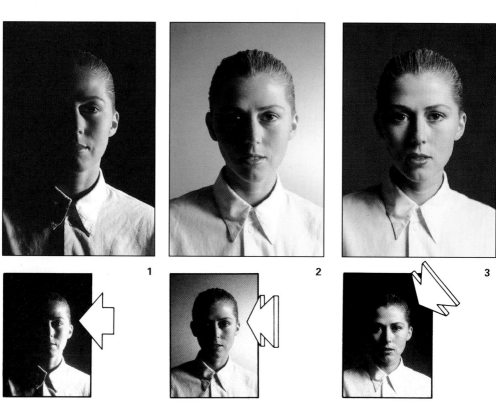

◀ Dramatic alternatives

Both these shots, although dramatically different in their approach, were taken using a single light. In the first version (1), I positioned a spotlight in front of the model and took the picture in profile. For the next one (2), the camera and model were in the same positions, but I directed a floodlight at the background instead. Both pictures: 85mm, 1/125sec, f/4

◀▲ Rimlighting

Rimlighting is used to separate the model from the background, creating a 'halo'; the light comes behind the figure. As I wanted to keep lighting simple, I used studio flash slightly to the rear to give some rim-light as well as sidelight. 120mm, 1/60sec, f/5.6

◀ Changing effects

In the first picture of this sequence (1), I directed a single studio flash at the side of the model's head. For the second one (2), the light was more to the front and some has spilled over and lit the background. For the last shot of the sequence (3), I raised the angle of the light to plunge the background into darkness again. All pictures: 120mm, 1/60sec, f/5.6

◀▲ Distance from background

The importance of having a flexible amount of studio space is demonstrated here. In the shot (above left), the model was 2m (6ft) from the rear of the studio and flash from the front was sufficient to illuminate the background. In the second version (left), I simply positioned her twice as far from the background and kept the lighting basically the same. Both pictures: 120mm, 1/60sec, f/5.6

LIGHTING AND EXPRESSION

For portrait photographers exclusively using black-and-white film, the advantages of tungsten lighting outweigh the cons. This is because there are no problems with colour balance – daylight can be mixed undetected with lamps. With colour film, flash and daylight are the best choices. The two light forms can then be mixed together.

Whichever form of lighting you use, reflectors maximize the number of possible set-ups, even if you only have one or two light sources. The control over lighting that a studio provides means that you can create moody images, contrasting dark and light areas, whatever film you use.

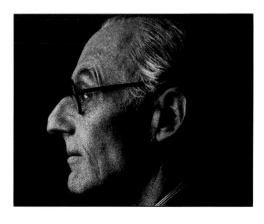

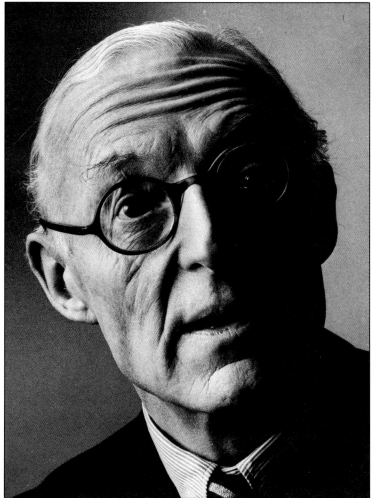

◀▲ Tungsten light
For these two portraits of Francis Bacon, inventor of the fuel cell, I used a tungsten-lighting set-up. This consisted of one floodlight pointing slightly downward at the face and another lighting the background. The intention was to capture an expression that hints at the depth and uniqueness of his work.
85mm, 1/60sec, f/4

▶Flash lighting
The energy and tenacity that characterize author Germaine Greer were more suited to flash. I used a studio flash and umbrella reflector to the right of the camera pointing at the face.
150mm, x-sync, f/5.6

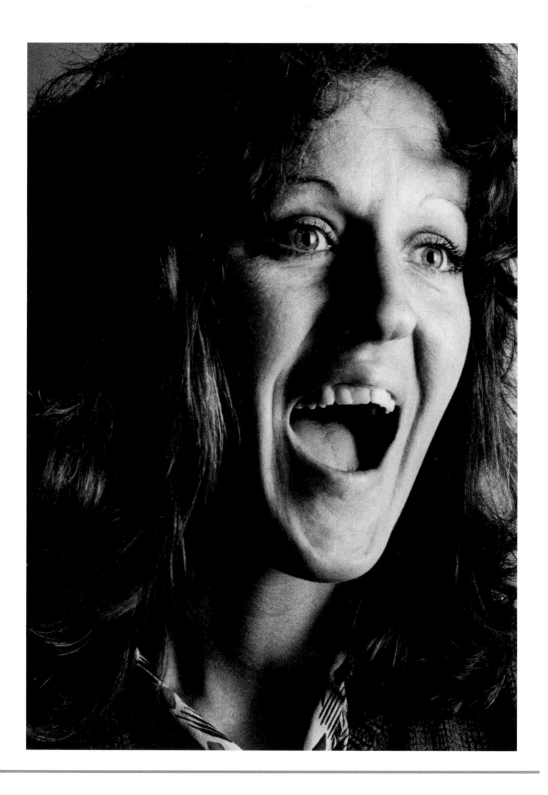

SELECTIVE LIGHTING

Having your own studio (even a temporarily converted spare room) gives you the opportunity to really come to terms with many of the challenges posed by lighting. The added benefit is that, once acquired, you will be able to apply this knowledge to most photographic situations, whether artificially or naturally lit. Also, in the studio it is possible to work at your own pace, trying new ideas or combinations of older ones, without worrying about the changeable nature of daylight.

An easy way of making your pictures stand out and catch the viewer's attention is by using studio lighting in a very selective manner. Instead of trying for a fully detailed portrait, use light to emphasize key areas of the composition and allow the rest of the picture, more or less, to look after itself.

By doing this you will, of course, be introducing a high level of contrast into the picture, and so you need to ensure that your subject is prominent enough not to become lost in the shadows.

EQUIPMENT NEEDS

All the pictures on these two pages could be taken using a maximum of three lights – two floodlights and a spot. In addition, you will also need some way to restrict the beams coming from the lights, so that you only light the areas you want to light: sometimes even a spotlight illuminates too much.

The most commonly used attachment for restricting the beam of light is a set of barn doors. It consists of four flaps that fit around the outside of the lighting head: each flap can be swung into position individually in order to mask the light beam selectively.

Another often-used attachment is a snoot – a conical arrangement narrowing to a small hole at the front that allows only a very narrow beam to emerge.

If you do not want to buy these attachments, it is relatively easy to make a cone out of thick cardboard and simply tape it to the lighting head. If you are using tungsten lamps, check periodically that the cardboard is not getting dangerously hot.

▲ Correct attire
In the picture above, one floodlight illuminated the background and another the face. Draping the model entirely in black and shooting from a low angle gave great presence to the figure. 28mm, 1/60sec, f/5.6

▶Darkroom technique

For this effect I used a diffused spot to light the girl's face and thus increase tonal separation between the two figures. During printing, I lightened her face further by giving it only 50 per cent of the exposure received by the rest of the print.
85mm, 1/15sec, f/5.6

◀Spot reading

By directing a spotlight on the model's profile, and allowing light to spill on to the background, a very dramatic effect is created. Exposure was calculated by taking a spot reading from the girl's lit profile.
85mm, 1/125sec, f/8

◀Mixed lighting

Here the background lighting is provided by the large window seen in shot. Rather than lighting the whole of the model's face, I have used a spotlight and snoot just to illuminate the eyes. This keeps the shape of the silhouette created by the ambient backlight.
50mm, 1/30sec, f/8

PORTRAIT
THEMES

85mm, 1/125sec, f/8

50mm, 1/60sec. f/8

A THEMATIC APPROACH

Portrait photographs that offer the viewer some insight into the character of the sitter are often easier to accomplish if you have in mind a particular theme to focus on before starting out. Portrait themes are as numerous as there are photographers, but some of the more achievable ones for the amateur are: different people all involved in the same sort of activity or profession, people and their possessions, people strongly associated with their environment, and people working at their particular hobbies.

The theme you choose will undoubtedly reflect your own interests, but the success of the pictures will depend not only on your ability but on the freedom sitters will allow you to experiment and roam within their homes or workplaces. Learn as much about each subject beforehand as you can – the work they do, the pictures they paint, the gardens they cherish, or the books they write. To make contact with these people, the photographer needs tenacity and self-confidence coupled with politeness and tact. Taking their interests as the prime consideration, however, should result in that essential co-operation.

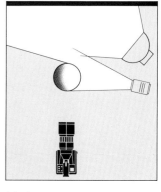

▲ ▶ Studio set-up
For this portrait of the cartoonist Illingworth, I used a long lens to concentrate attention on his face and lit the background with a floodlight, as shown above. A spotlight on the right brought out all-important facial details. 120mm, 1/60sec, f/5.6

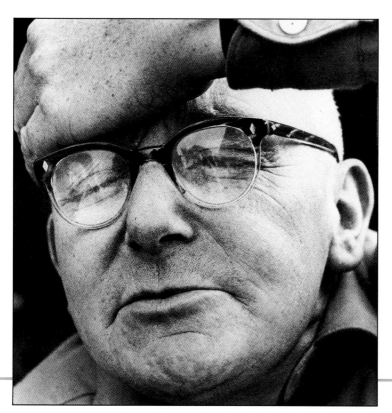

◀ Natural light
Utilize the type of light and setting best suited to your subject. For this study of the cartoonist Giles, we moved outdoors into an area that gave a soft, directional light filtering between two buildings. This provided good modelling and produced a relaxed atmosphere ideal for a portrait session. 120mm, 1/250sec, f/8

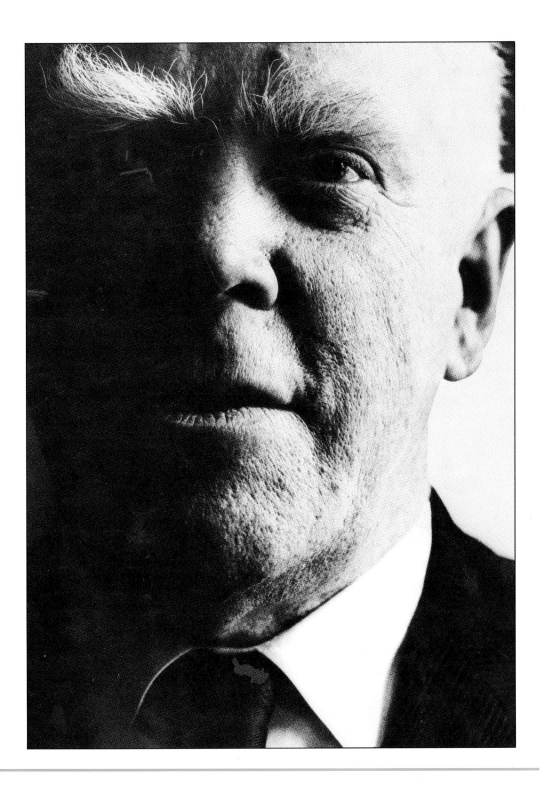

MAKING CONTACT

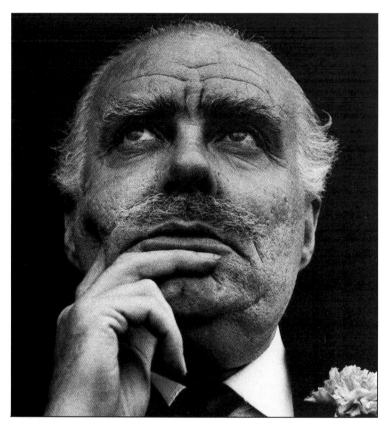

▼ Three-quarter view
This framing makes the face of political cartoonist Low shade off into darkness, emphasizing the fleeting atmosphere of this study. The cupped hand, seemingly as disembodied as the head, is also a factor in achieving this. 85mm, 1/125sec, f/5.6

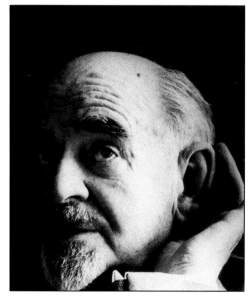

The photographs on this page and opposite are all of press cartoonists. There is no use pretending that access to people such as these is easy, and your first approach should be by letter via the publication their work appears in.

In your letter, explain fully who you are, why you want to take the pictures, how the pictures will be used, and how much time you estimate the session will take. Be realistic here: nothing is more annoying than setting aside 45 minutes for something that ends up taking hours.

If contact is established, arrange either to travel to the subject's home or place of work or, if you prefer and he or she is willing, your home or studio could be the venue. Things will go more smoothly if you can meet the subject before the session and survey the location. Once you have been successful with one person, it will give you more credibility with others.

◄ Close framing
Moving in close to almost fill the picture area, and using a low viewpoint magnifies the strong presence of Osbert Lancaster. The subtle detail of the carnation picked out against a uniformly black background emphasizes the style and elegance of the man.
85mm, 1/60sec, f/8

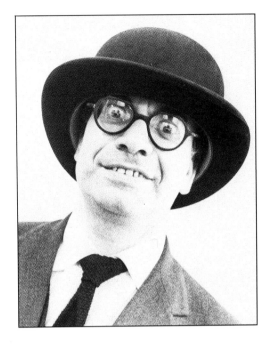

◄ Eccentric appearance
Vicky thrusts his head into an overly large bowler hat that a victim of one of his cartoons had sent him. Supposedly a 'big head', Vicky has turned the portrait into a joke. The angled composition adds to the drama.
80mm, 1/125sec, f/8

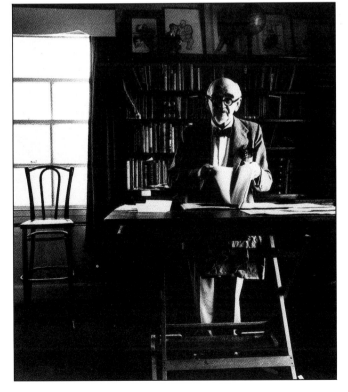

◄ ▲ Intersection of thirds
This portrait of Low derives its restrained atmosphere from a geometric interpretation of the scene. The diagram above shows how the cartoonist is situated on an important vertical line and his head at an intersection of thirds. Placing focal points off-centre usually creates a more vibrant composition.
80mm, 1/125sec, f/5.6

LONG-TERM THEMES

The camera is a unique recording instrument: point it at virtually any subject, press the button, and you capture forever a frozen instant of time. But how much more meaningful those images can be is made plain when you see a progression of pictures of the same person taken over a long period of time. In this way you record not only the passage of the years but also that person's life's work and leisure interests.

WHO MAKES A GOOD SUBJECT?

Anybody is a suitable candidate for this type of photographic approach. The pictures here, and on the two pages overleaf, are of the great British sculptor Henry Moore. But the object here is not to reflect fame for its own sake; rather it is to make a record that communicates more than any single shot could ever hope to achieve. The series should also explore a chosen theme – and should be a process that brings pleasure to both parties.

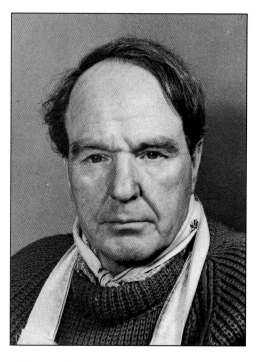

▲ **Artistic prime**
This picture shows Henry Moore in his vigorous middle years, when his work was already highly acclaimed.
50mm, 1/125sec, f/4

▶**Lost in thought**
As we had become firm friends, there was no awkwardness at all when I brought the camera out for this picture. I do not think that he was even aware that I had taken it.
135mm, 1/60sec, f/5.6

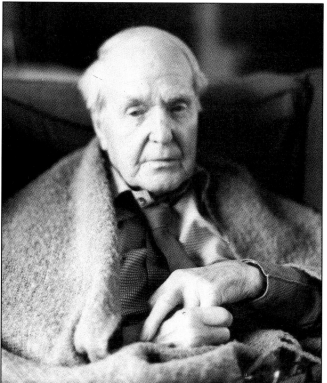

◀ **Twilight years**
My intention here was to emphasize the gentle nature of the man, so I used an open aperture to soften the already diffused light entering from a window on the left.
50mm, 1/60sec, f/2.8

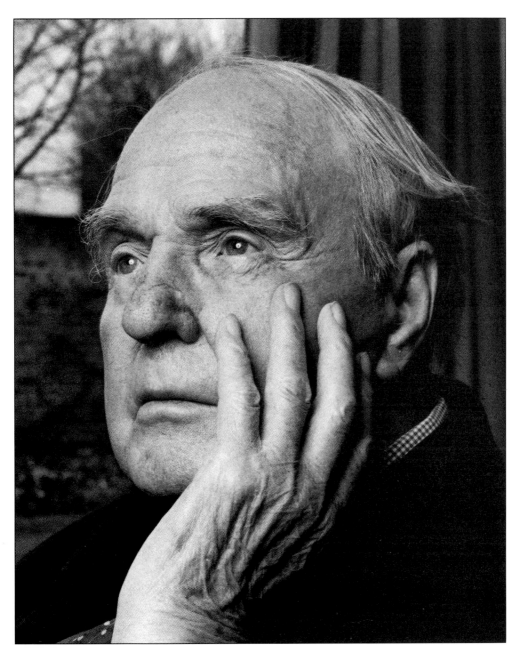

ESTABLISHING THE GROUND RULES

A series of pictures comprising a long-term project such as this should be of somebody you have easy access to – perhaps a member of your family or a close friend. Interest needs to be maintained over a very long period if the photographic record is to be complete.

In a way, the family photograph album goes some way to fulfilling the objectives of projects such as this, but usually an album is not totally satisfactory, since it chronicles certain aspects only – holidays and special occasions such as graduations, weddings, and so on. But here, events are not our main concern. It is often the quiet, introspective

LONG-TERM THEMES

moments and those times when your subject is engrossed in some ordinary activity, and when his or her guard is down, that will provide the best insight into character and most poignant memories.

TYPES OF COVERAGE

There is no particular need to try for candid pictures. To ensure that you obtain the shots you are after, you may need to enlist the support of your subject by asking them to pose in a certain way. The self-consciousness that can result from pointing a camera at somebody may even be worth capturing.

Over the years you could build up a sizeable portfolio of pictures – too many to be really appreciated. So right from the beginning, be selective in what you take and certainly in what you include in the project. And with so many pictures you will want to show a good range of different approaches to the subject – close-up and distant shots, formal and informal, posed and unposed, and indoors and outdoors. Your pictures should aim to record not only your subject's leisure activities but also his or her more active moments.

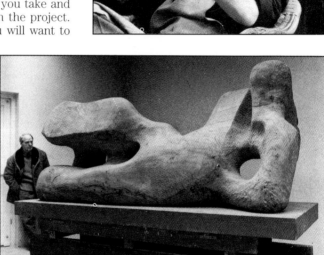

▼ **Adopting a pose**
Henry Moore posing in front of a newly completed sculpture is the traditional way of portraying the man and his work.
28mm, 1/500sec, f/8

▲ **Scale and perspective**
When considering a long-term project involving a pictorial record of a person's life, it is important to include shots such as these above, that show the viewer important aspects of the subject's work. These two are of particular interest because they show the varying scale of the sculptures created by Henry Moore – in the picture above he appears completely dominated by the reclining figure, while in the other at the top he is the most prominent element.
Above: 28mm, 1/60sec, f/5.6
Top: 85mm, 1/125sec, f/11

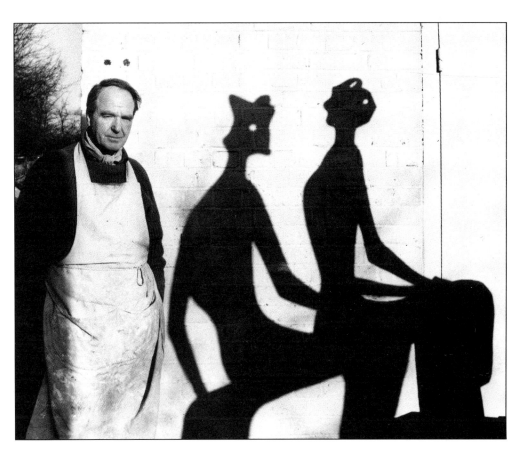

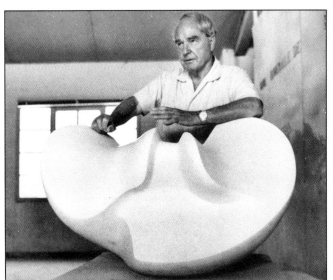

▲ Varying the approach
For this shot, posing Henry Moore alongside the shadow cast by one of his works gave a new slant to the subject.
80mm, 1/500sec, f/8

◄ Relaxed pose
Even after all the years I knew him, Henry Moore was still at his most relaxed when posing with one of his sculptures.
120mm, 1/125sec, f/8

PRIDE OF POSSESSION

Since the principal aim of portraiture is to reveal something of the character of the subject, the depiction of that person's prized possession – their home, for example – must help considerably in conveying personality.

This approach to portrait photography means getting out of the studio. Furthermore, since you will have to cope with the unexpected, you should have with you as a minimum a wide-angle lens, moderate telephoto lens, and a standard lens, as well as a few rolls of spare film.

FOUND SUBJECTS

Usually you will find that people are only too willing to show their possessions to the camera. There is, after all, an element of pride involved. Much, though, will also depend on your approach: a bold, confident invitation to pose will often produce better results than a surreptitious, snatched candid shot. Some people will, of course, be self-conscious, but that in itself can make for good pictures. Other people, by the very way they dress or behave, can court the attention of the photographer.

COVERING YOURSELF

Although many of the pictures of this type are repeatable, for those that you just come across it is best to shoot more film than you think you need, varying the composition and exposure. In many cases, your first shot will be the one you finally decide is best, but if you have the time then bracket exposures a half and one full stop either side of the metered reading to guarantee a good result.

▶ **Green fingers**
This gardener obviously took a lot of pride in his work, and I therefore wanted to photograph him with some of his best winter blooms. To include the poinsettia in the foreground without it appearing completely out of focus, I used a split-field attachment in front of the lens. This bifocal device magnified the foreground, whilst leaving the top of the picture untouched.
50mm, 1/60sec, f/16

◀ **Proud owner**
After their homes, a person's car is usually their most valuable possession. In this picture I have shown both. The diagonal positioning of the car and its leaning owner draw the eye in an otherwise symmetrical composition.
50mm, 1/250sec, f/8

▶ **Tidy garden**
The hard work this lady puts into her garden is symbolized by the broom in her hand. A garden often makes a good setting for a portrait, as it provides natural light and an interesting foreground, whilst allowing you to use the person's home as a backdrop.
35–70mm, 1/60sec, f/5.6

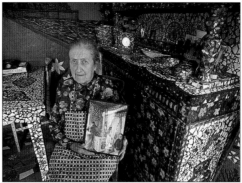

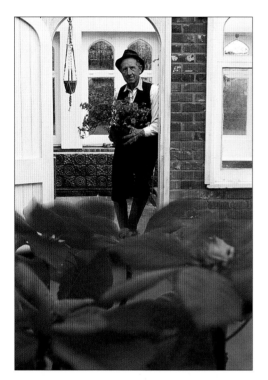

▲ In the home
People's homes are often a treasure trove full of beautiful, bizarre and unexpected objects. In this shot, I asked the lady to sit amongst her extraordinary mosaic furniture, creating a colourful backdrop for my portrait.
35–70mm, 1/30sec, f/11

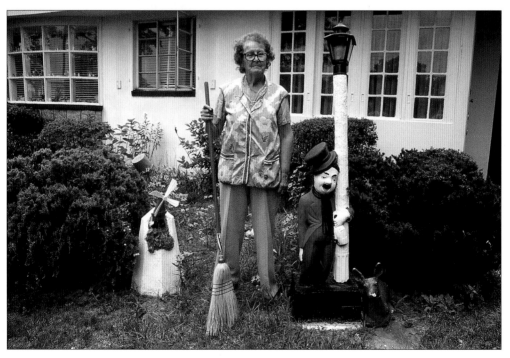

COUNTRY LIFE

Adopting a theme for at least some of your portraiture is even more fulfiling when it represents a valuable documentary statement. A good example of such a theme might be the disappearing way of life of our rural areas. The impact of mechanization and technological advance, as dramatic as it has been in the great industrial centres, has had a devastating effect on country life, where whole communities of farmers and farm workers have simply faded away. Some of those who do remain feel themselves to be the guardians of past traditions and may be willing subjects for your camera.

As is often the case with portraiture, much depends on how you make your initial approach. You will achieve far more if you are fully committed to making a sensitive photographic record of individuals' lives and interests before they are gone forever. You will inevitably be working on location, so restrict your equipment to a minimum – two camera bodies, three lenses (or a wide-ranging zoom), spare film and batteries, filters, flash, camera and lens cleaning equipment, and a tripod.

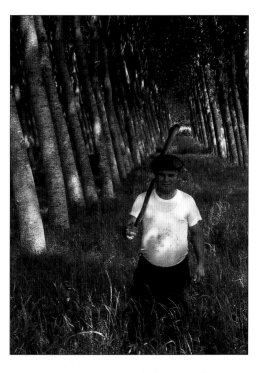

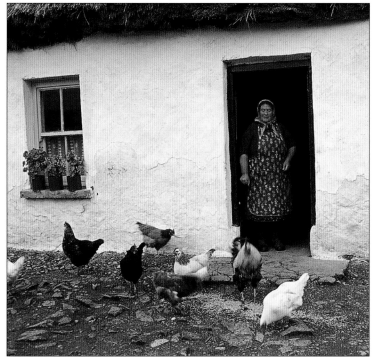

▲ Down the line
*The lines of trees in this shot make a perfect backdrop for a portrait picture – with the converging rows drawing the eye through the picture.
35–70mm, 1/60sec, f/8*

◀ Man and beast
*Part of the rural way of life is that animals and humans live side by side – sharing the same scenery and roads. However, they don't always live as closely to each other as this woman and her chickens.
35–70mm, 1/125sec, f/5.6*

► Time to talk

You don't need to visit farms to photograph the people who live and work on them. Markets and country fairs provide an ideal opportunity to capture candid shots of rural folk interacting with each other.
35-70mm, 1/125sec, f/8

▼ Get inside

As farm houses are lived in by one family for generations, you can often find that their interiors transport you back in time. In this picture, the farmer's wife posed in front of the old range, which provided the main focal point for family life.
35–70mm, 1/30sec, f/4

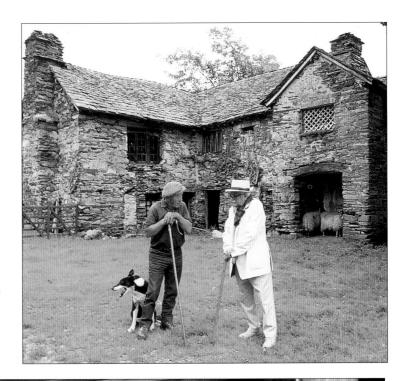

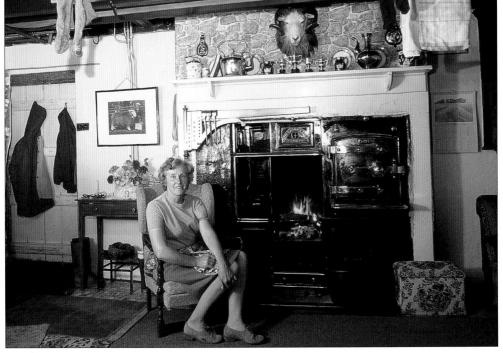

PEOPLE AT WORK

One of the main problems associated with portrait photography is that people tend to freeze up as soon as you point the camera at them. One of the best solutions to this is to tackle them when they are feeling completely relaxed or confident in what they are doing. More often than not, this is when they are at work and feeling more in charge of the situation.

Another approach would be to try for candid pictures using a long lens. But then you miss out on the interaction between subject and photographer that, in many cases, marks the difference between a record shot and a revealing portrait.

If what you are trying to achieve is a generally interesting portfolio of pictures, as well as featuring people as the main subject, then it will help if you can research and then track down people who have unusual types of occupation. Not only will your pictures benefit from the effort you put in, but you may also find that your pictures have some historic value as many of the old crafts and working practices are being replaced by automated, soulless machines operating in sterile environments.

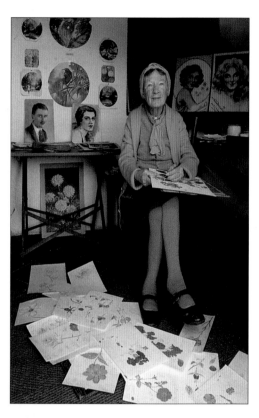

▲ **Showing the fruits of their labour**
To show that this lady illustrates flowers for a living, it was no good just shooting her at work. Using a wide-angle lens, I included a selection of her paintings in the foreground. 28mm, 1/15sec, f/8

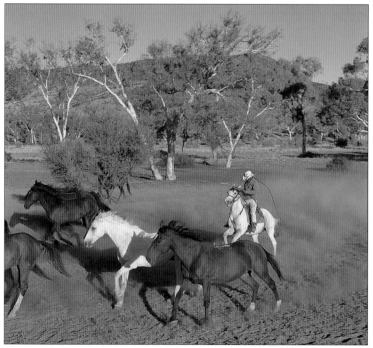

◀ **Capture the action**
When possible, it is worth trying to capture active shots of your subjects, rather than just still poses. This approach was no problem for this portrait of a rancher. 35–105mm, 1/500sec, f/8

▶ Using props

Asking subjects to hold one of the tools of their trade helps to add interesting shapes to a picture, as well as suggesting what they do. 50mm, 1/60sec, f/4

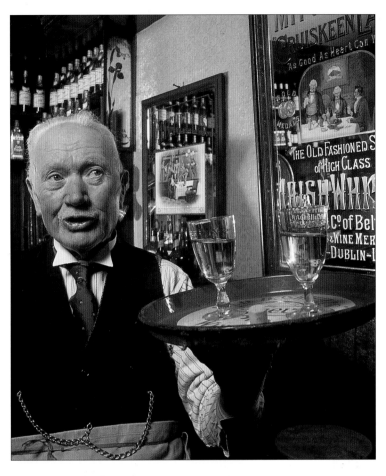

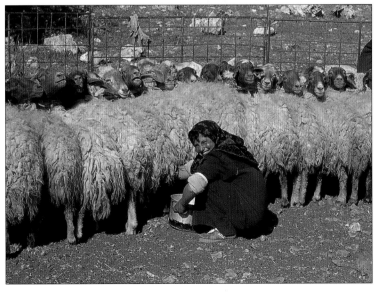

◀ Don't crop too close

It is often tempting to use a longer lens, zoom in or move closer, so as to concentrate the view on the subject's face. Doing this, however, often means that interesting, and informative, detail is lost from the shot. Here the wider view of this milkmaid in Jordan allows us to see the line of sheep's faces. 35–70mm, 1/250sec, f/8

THE MUSIC MAKERS

▲ **Young musician**
When photographing children, it pays to kneel down, so that you are shooting from their eye level.
85mm, 1/60sec, f/8

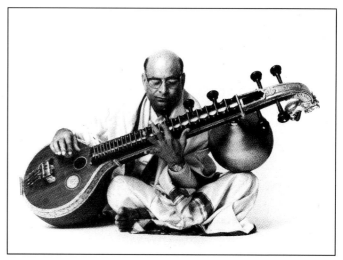

▲ **Sitar player**
A neutral setting increases the level of concentration the viewer is able to give the details in a shot.
50mm, 1/60sec, f/5.6

◄ **Hard blow**
Unintentional humour has been created in this close-up of a tuba player, with his bulging cheeks and popping eyes.
80mm, 1/125sec, f/11

▲ **Concentration**
When setting up shots of musicians playing their instruments, it is better that the subjects do not look towards the camera.

This helps give the impression that they are completely absorbed in their music.
80mm, 1/125sec, f/8

PHOTOGRAPHING FACES WITH CHARACTER

Taking portraits of either the very young or the very old presents a challenge to the photographer. With elderly people, gone are the physical attributes that are generally regarded as attractive – firm skin, clear eyes, and lustrous, flowing hair. Instead, you will have before the lens, etched in your subjects' faces, a mirror reflecting their many years and a wealth of experiences.

The results of your endeavours need be no less beautiful simply because the magic ingredient of youth is no longer present – you will be amply rewarded in other ways.

STUDIO OR LOCATION?

From a photographic viewpoint, if you use a telephoto lens, with a focal length of up to 135mm, and allow the subject's head and shoulders to fill the frame, then, as the pictures here and on the following two pages show, it does not matter much if you are in a studio, at your subject's home, or outdoors.

In general, you will find that the elderly prefer the security and comfort of their own homes, so get together a basic, yet flexible, kit of equipment that you can take with you. If you can visit the location beforehand, you will

►Contrasting styles
A dark background adds a sense of drama, which is in keeping with the shot of actress Margaret Rutherford (right). A lighter backdrop is more sympathetic (far right). Right: 85mm, 1/60sec, f/4 Far right: 135mm, 1/125sec, f5.6

◄In the shade
When shooting outdoors in bright sunlight, you can avoid harsh light by positioning the subject in the shade. 70–200mm, 1/125sec, f/5.6

◄Dappled light
The shade of a tree produces intense highlights, spotlighting parts of the face, which is otherwise indirectly lit. 70–200mm, 1/125sec, f/8

►Tonal separation
A good trick is to use a contrasting tone to separate your subject from the background. Here the dark headscarf separates the woman's face from the similarly-toned background. 120mm, 1/60sec, f/4

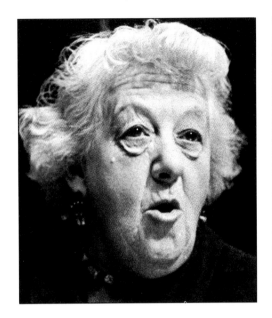

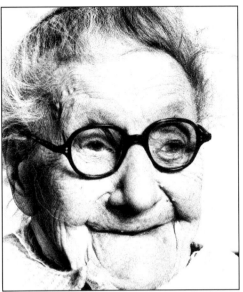

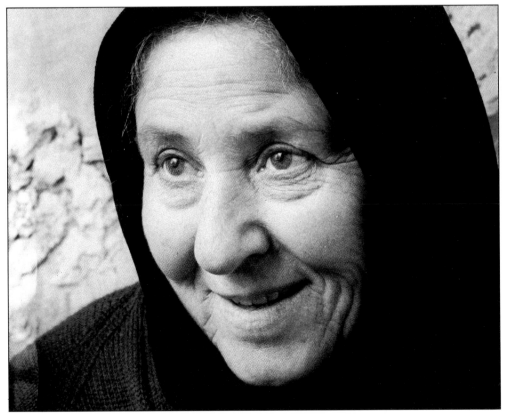

PHOTOGRAPHING FACES WITH CHARACTER

be able to gauge your needs accurately. You should avoid pointing lights directly at people's faces, so you will have to rely on bounced or reflected light.

Look at the surroundings to see if there is the option of outdoor pictures. A balcony will do if there is no garden. If you need power for lights, check where the points are and then take extension leads with you if necessary.

CONCEALING BLEMISHES
It would not be fair to assume that male subjects are more robust or less vain than female ones, so you need the same level of consideration for both. One of the objectives must be to produce photographs that the subjects find pleasing, and when working with a man you can afford to allow lighting to be a little more contrasty, relying more on sidelight and reflectors. Facial lines, skin blemishes, and even exaggerated features tend to be regarded as characterful.

Such features, however, will probably be thought unflattering by women in portraits of themselves. Minor skin blemishes can, of course, be minimized or hidden with make-up. But the best asset you have as a photographer is the quality of light. Try for even illumination. basically coming from the front of your subject. Alternatively, you can use a bright highlight in order to burn out a detail you do not want seen.

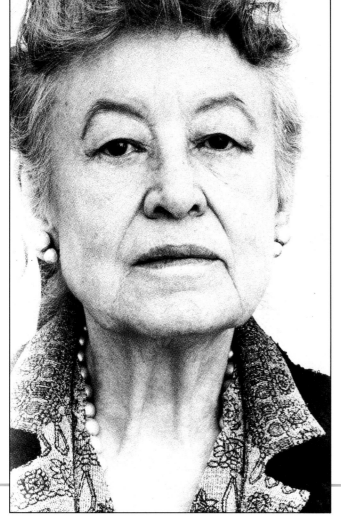

◀ Supplementary flash
Soft frontal lighting is often the most flattering for lined skin. For this picture, I supplemented gentle winter sunlight with heavily diffused off-camera flash. 85mm, x-sync, f/8

▶ Direct sunlight
Standing with the sun behind you is a good way to get the best colours in your pictures. However, it is not ideal for portraits as the strong light makes people's eyes squint. This is less of problem with full-length portraits, as the facial features are less noticeable. In this shot, further emphasis has been taken from the eyes by the strong shadow cast by the couple's hats. The result is the picture becomes more a study of shape and form; it shows the togetherness of husband and wife, rather than revealing individual identities. 35–70mm, 1/250sec, f/5.6

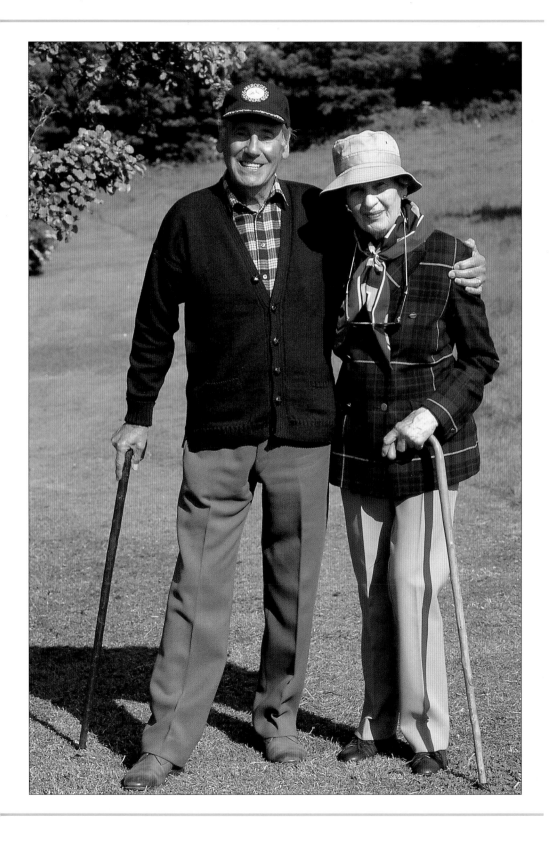

WINDOWS AND DOORS

A photographic theme does not necessarily have to revolve around people involved in similar occupations or sharing the same activities or interests. The connection between the people can be produced by the photographs themselves. Equally valid are themes where people are seen in particular aspects of their environment. This could be a particular place, or something more abstract. Architectural features, for example, can be used to provide varied and interesting backgrounds.

Windows and doors are commonly exploited by photographers for compositional purposes. They not only make convenient framing lines, but are also extremely revealing of class and social status. Bear in mind, though, that you need to include sufficient of the surroundings to balance the size of your subjects.

Sometimes you may want to photograph somebody framed in an upper-floor window. Pointing a normal lens up from ground level would result in the familiar problem of converging vertical lines. The solution is to use a shift lens, which allows a limited range of movements to correct for this distortion.

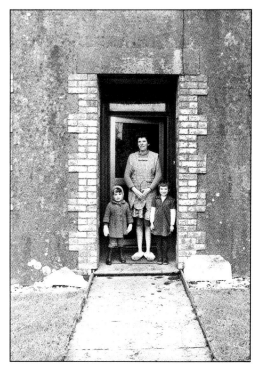

▲ Confining the subject
In this shot, the door and doorway effectively confine and frame the woman and children.
50mm, 1/250sec, f/16

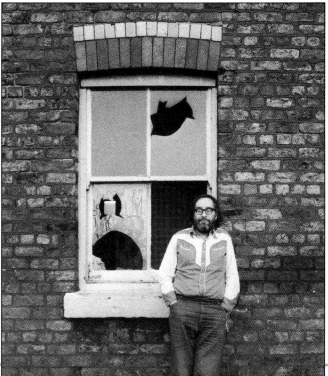

◀ Derelict façade
The broken glass adds a sad note to this picture of the poet Adrian Henri and the Liverpool house he was born in.
80mm, 1/125sec, f/4

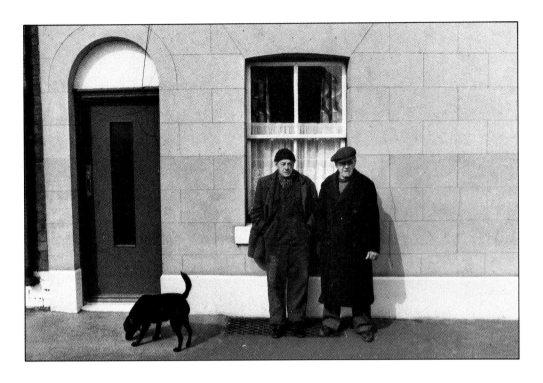

▲ Balancing tone
*Here, the doorway and the window
help to balance the dark tonal
mass of the two figures.
28mm, 1/125sec, f/11*

▶ Converging verticals
*An already massive window is
made to appear even larger by
shooting from a low camera
angle with a wide-angle lens.
28mm, 1/60sec, f/8*

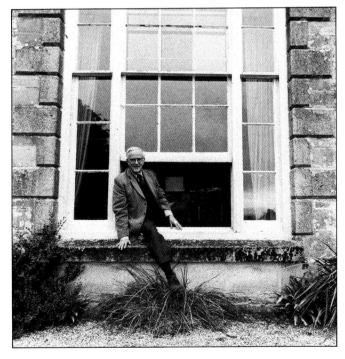

LOCATIONS

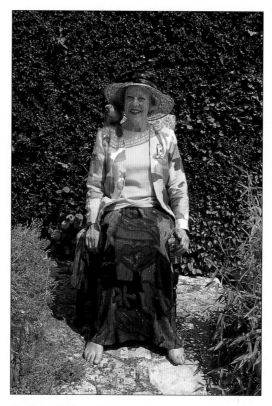

35–70mm, 1/250sec, ƒ/5.6

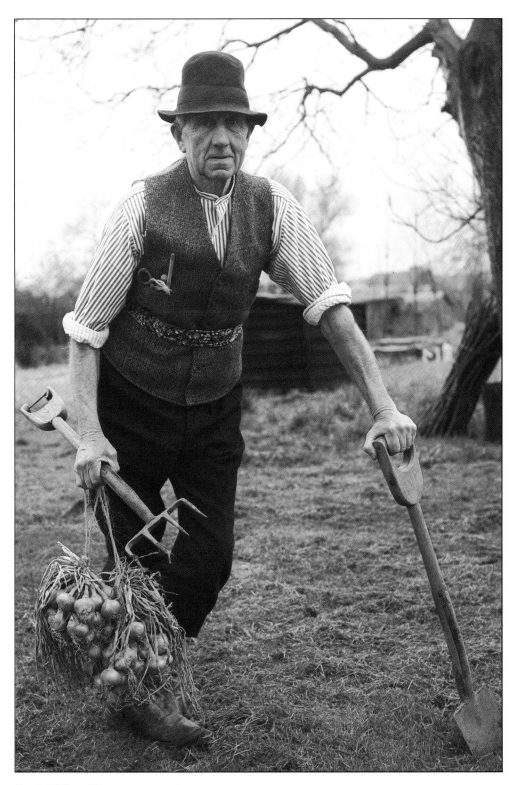

80mm, 1/125sec, f/11

ON LOCATION

For the photographer, sessions on location bring an informality that is often hard to achieve in the studio. Subjects tend to be more relaxed, and the resulting shots may reveal fresh aspects of their personalities.

However, outside the studio you no longer have complete control over the photographic environment, and quality of light becomes a major factor.

LOCATION WORK

A sturdy equipment bag is an essential for serious location work. It should be lightweight for easy carrying, and made of weatherproof material padded with foam to protect your equipment from accidental shocks. As well as ample space for cameras, lenses, filters and packs of spare film, there should be pockets to carry odds and ends, such as notebooks, adhesive tape, cleaning agents and spare batteries. In addition, most bags have straps for carrying a small collapsible tripod.

For more ambitious location shoots, the equivalent of a modest studio will be required, with portable lighting arrangements of varying sophistication, all of which can be rented by the day.

▼ Have lights, will travel
For this picture taken during the Venice carnival, I wanted to take advantage of the low afternoon sunlight. Backlit, the unmistakably Venetian scene takes on a painterly feel. But in order to capture the brightly-coloured masks I also needed some frontal fill-in light. This was provided by a portable flashgun, which provides enough illumination outdoors during daylight hours, as long as the subject is only a few feet away. 35–70mm, 1/125sec, f/4

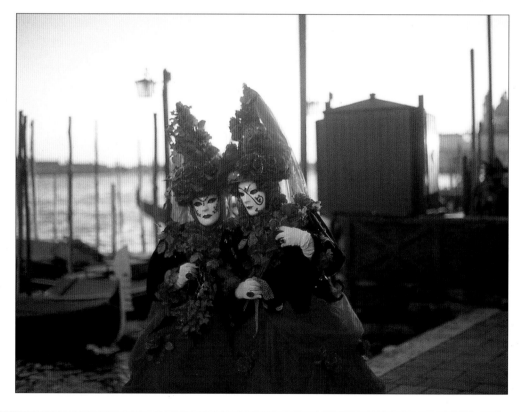

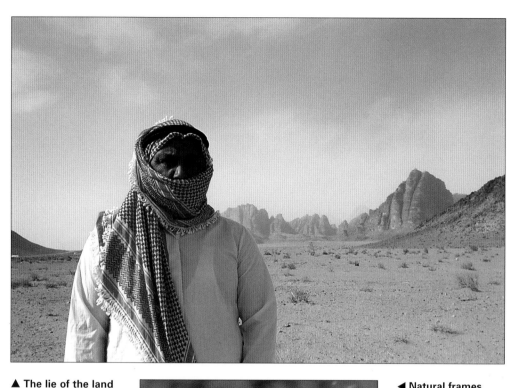

▲ The lie of the land
A panoramic view, of course, can make a picture in its own right – but it can also provide a good backdrop for a portrait study. So that the background is not too distracting, it is best if the landscape adds something to the meaning of the portrait. Here, the arid desert tells us about the subject's native land.
35–70mm, 1/500sec, f/8

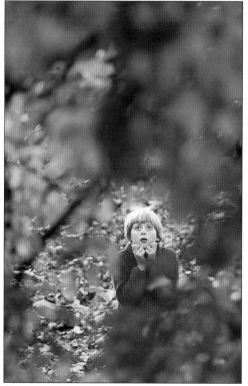

◄ Natural frames
Branches of trees and foliage can often be used to create a frame for your picture. This natural foreground adds variety to your portraits, and also helps add the missing third dimension to your two-dimensional photographs. In this shot I have taken advantage of an elevated camera position; by looking down on the boy, his look of bewilderment is accentuated.
35–70mm, 1/125sec, f/5.6

USING EXTERIORS

Portrait photographs that show just a simple likeness of your subject are very different in mood, and in what they tell you, from those taken in an environment relating to the person's lifestyle. Once you place a person in context – at school, college or at play, for example – the image is at once richer and more complex. You do, however, have to ensure that the photograph still fulfils the function of a portrait, in that the person or persons portrayed are recognizable. The danger is that you will produce a shot of an exterior with people in it, rather than a picture of people in an exterior setting. This is a fine line you have to tread.

Choice of lens, viewpoint, and lighting are the main factors that determine how your photograph will be viewed. Even in quite elaborate settings, adopting a high or low camera angle will help to draw attention to your main subject while still maintaining the feel of the place. It is also useful to create a strong contrast, either of colour or tone, between your subject and setting.

In such situations, the angle of view of a standard lens is probably best: a wide-angle lens might make your task more difficult, unless you move in very close. With telephotos, of course, the much narrower angle of view of the lens means that you will exclude much of the setting.

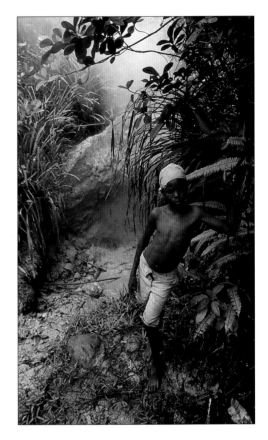

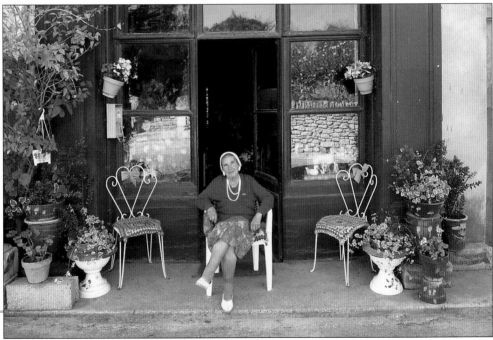

◀ **Splash of pink**
A brightly-coloured hat immediately catches the eye in this dark, low-key, photograph. Without this, it would take the viewer longer to find the focal point for the shot.
35–70mm, 1/30sec, f/5.6

▶ **Wide view**
A wide-angle lens helps give the young subjects a dominant position against the grand architectural backdrop.
35–70mm, 1/60sec, f/8

▼ **Letting the exterior dominate**
For portraits, you don't usually want the exterior to take over the photograph. With this curiously-shaped building I made an exception, keeping the subject small so as to include the whole facade. The colour of the clothes, however, catches the eye.
135mm, 1/250sec, f/8

▶ **Period setting**
The ruin in this picture acts as a suitable back-ground against which to photograph this troop of re-enacting soldiers.
35–70mm, 1/250sec, f/8

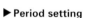

◀ **Symmetry**
Having seen the symmetrical way in which the flowers and chairs were laid out in front of this house, I thought I would try to imitate this structure in my picture. To maintain the balance, the owner sat in the middle of the scene.
35–70mm, 1/250sec, f/5.6

USING EXTERIORS

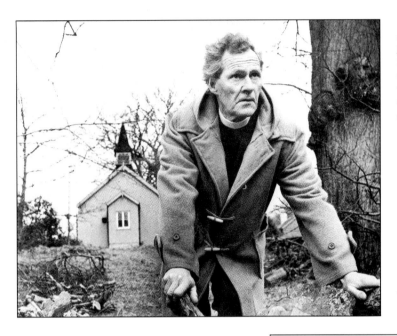

◄ Careful framing
In this portrait of the poet and vicar R. S. Thomas, I chose an outdoor setting to relate him to his country church..
35mm, 1/60 sec, f/11

► Garden setting
The setting could not have been more appropriate for this shot of writer and horticulturist Vita Sackville-West – the Sissinghurst garden, in Kent, that she made so famous.
50mm, 1/125sec, f/11

▼ Back to nature
The artist Graham Sutherland was pruning his apple trees when I arrived. As he often used natural forms as inspiration for his work, I took some shots in an attempt to convey this.
120 mm. 1/60 sec, f 5.6

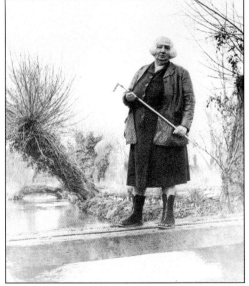

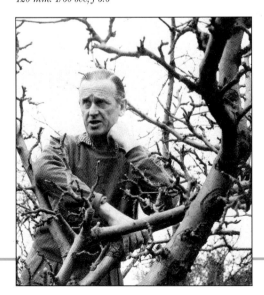

▲Tonal values
I posed authoress G. B. Stern in her frost-covered garden. As she was a formidable lady, I thought her figure would appear stronger in the photograph if it contrasted against the near-white background, creating a high-key effect.
80mm, 1/60sec, f/8

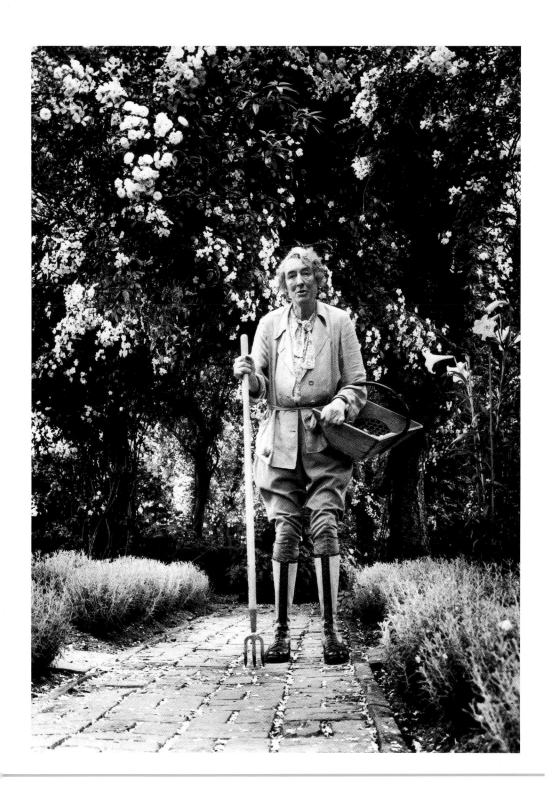

USING INTERIORS

Interiors can add considerably to the structure and interest of a portrait. You stand a better chance of capturing your subject in a more characteristic attitude if the interior is one they are familiar with – such as their home or place of work. There are still basic decisions to make about whether the shot should be formal or informal, but these problems will often resolve themselves once you make a start.

Unless you intend to rely on artificial tungsten lighting and exclude daylight (an approach which may rob the picture of some of its spontaneity), be wary of introducing too much contrast. This occurs when window light is the only source of illumination. To reduce any excessive shadow areas, try using supplementary light in the form of flash. Another way of introducing more light is to replace the existing lightbulb with a photoflood. To shoot in existing light use a fast lens or fast film, or alternatively use a monopod or tripod with a slow exposure of 1/4 to 1/15 sec.

Another factor to consider is the colour of your surroundings. In the studio, you will have white- or neutral-coloured walls, but on location you may have to deal with coloured walls and ceilings reflecting colour casts over your subject. Mixed light sources also create colour casts.

▼ Natural effects
If you have to use artificial light indoors, it pays to make it look as natural as possible. For this club scene I positioned a pair of portable studio lights to the left of the camera, covered with large 'soft box' reflectors. This gives the impression that the men are being lit by light from windows.
80mm, 1/60sec, f/8

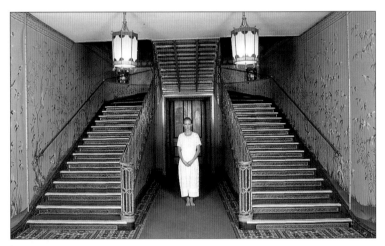

▲ Artificial daylight
Although this shot was lit with daylight-balanced flash, I still wanted the lightshades in the hall to glow. To do this I combined the flash with a slower-than-normal shutter speed.
28mm, 1/8sec, f/8

▶ Existing light
This room was perfect for an interior shot without flash. Not only was there a large window, but the white walls and ceilings acted like huge reflectors to soften the shadows.
35mm, 1/15sec, f/8

USING INTERIORS

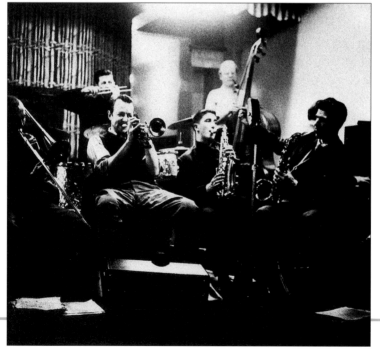

▲ Window light
The huge windows around this room meant that there was plenty of light for this photograph of Lady Hamlyn. The contrast, however, proved a problem and I had to use additional flash to get the lighting balanced. 50mm, 1/15sec, f/16

◄ Subdued lighting
With this group portrait of a jazz band at rehearsal, the natural light was important to convey the relaxed informality of the players. I used a fast film, rated at ISO 1600. 50mm, 1/60sec, f/4

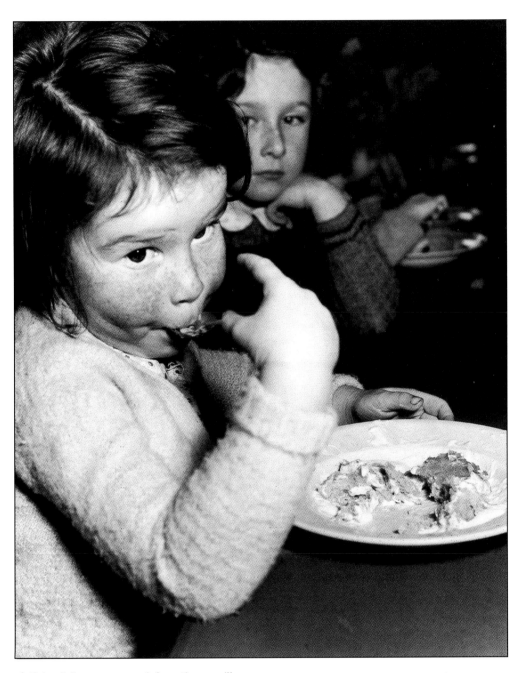

▲ **School dinners**
Sometimes you want to suggest the interior setting without letting it intrude too much. Using a long lens will help you remove extraneous information, as will a shallow depth of field. Also, with a telephoto you can stand well back and not intrude.
85 mm, 1/60 sec, f/4

DOMINANT SETTINGS

Perhaps the prime objective of portrait photography is to convey to the viewer something of the personality of the subject – to go beyond the technical exercise of simply producing a good likeness. One of the best ways of achieving this is to show your subject in a strong setting.

Advice is often given on the benefits of avoiding cluttered pictures, where the attention of the viewer is drawn in different directions and the subject therefore 'diluted'. In many cases, though, the setting has a lot to add to the photograph.

Giving emphasis to the subject in a setting is a matter of composing your shot correctly: moving the camera a little to the left or right, up or down, can bring new elements into the frame and produce a tension that is so often missing in straight portrait pictures. An important part of the photographer's role is to use the camera's focusing screen to experiment with the various components of the shot. What you decide to retain or leave in sharp focus will have much to do with the atmosphere you wish to create.

COMPOSITION TRICKS

Line can represent an extremely dominant feature in the setting, helping to draw the viewer's eye precisely where you want to fix attention. Strongly vertical lines tend to emphasize the height of the picture; horizontal lines, on the other hand, produce a static composition, fixing attention on anything placed at their junction.

Bright colours and dark tones seem to come forward in a picture, while muted colours and lighter tones tend to recede.

When deciding on how to arrange the picture, be careful of using settings that are flat toned. Apart from offering little visual interest, a light-toned figure in a dark-toned setting will appear disconnected, almost floating in the environment.

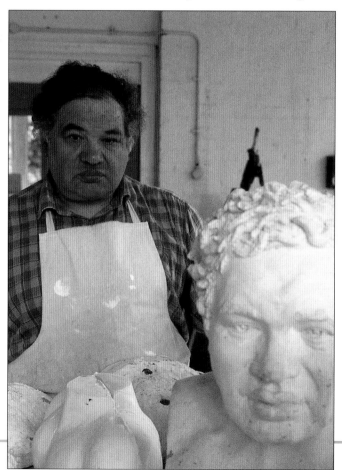

◀ **Dominant foregrounds**
Much of the character of the artist Eduardo Paolozzi is reflected in this photograph. He has a powerful physical presence, and this is suggested by his sculpture, which, although dominating the foreground area of the picture, does not deflect attention from him.
85mm, 1/30sec, f/8

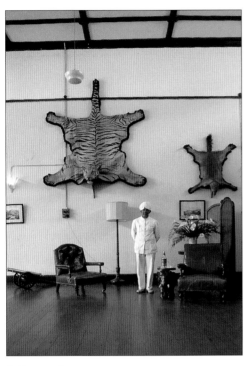

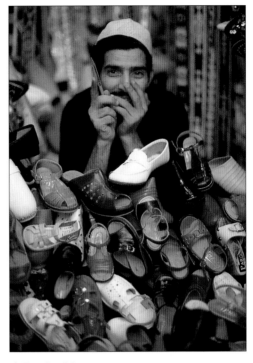

▲ Proper placement
In this shot, the impressive animal skins dominate the scene. I posed the man in the bright white suit to balance the composition and draw the eye into the subdued tones of the room.
28mm, 1/30 sec, f/5.6

▲ Emphasizing the foreground
Using a wide aperture in this subdued natural light has emphasized the foreground shoes, making them the dominant element in the scene – and immediately telling us what this shopkeeper is selling.
50mm, 1/60sec, f/2.8

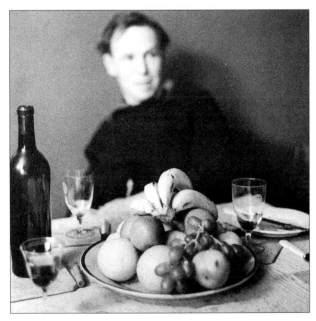

◀ Depth of field
One way to emphasize elements of a picture is to use a limited depth of field to throw everything else into soft focus.
50mm, 1/60sec, f/1.4

ROMANTIC SETTINGS

Romantic settings conjure a very specific mood and they often have an air of mystery about them. But the predominant quality in what is popularly regarded as 'romantic' is that of softness. This has as much to do with colour as it does with lighting quality. But romantic imagery also depends on your subjects and the way they present themselves to the camera – for a hint of innocence is necessary, too.

LINE AND COLOUR
In general, flowing, continuous lines make for softer images. Sharp, discontinuous or jagged lines create tension, and that is definitely to be avoided. If you are posing the shot, then think about using loose-fitting garments that will fall into sweeping folds and so accentuate body lines.

Water is often associated with romantic settings, and provides the opportunity to use reflections – slow-moving or slightly disturbed water produces wavy, flowing patterns, echoing the shape of your subjects.

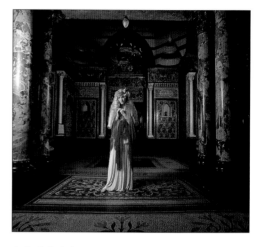

▲ Soft lighting
If the window area is large enough, window light can produce a perfect type of illumination for romantic imagery. Here, however, I reproduced this type of effect using diffused flash.
80mm, 1/15sec, f/16

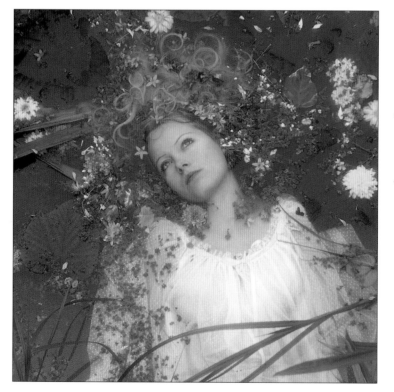

◄ Classic imagery
This shot draws heavily on paintings depicting Shakespeare's Ophelia. The set was nothing more than a small, inflatable swimming pool with a few inches of water – just enough to submerge the model partially. What took most time was decorating the pond with flowers and water plants.
120mm, 1/125sec, f/2.8

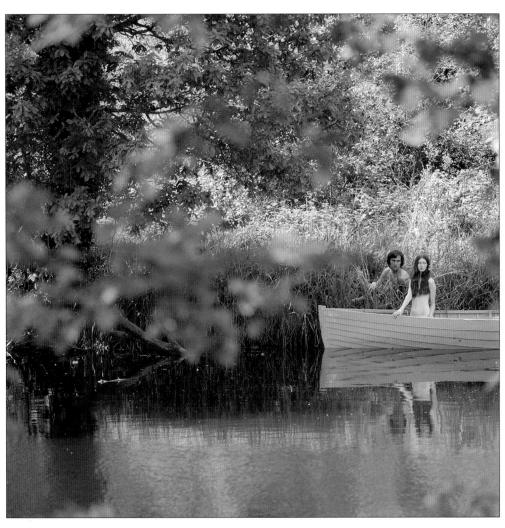

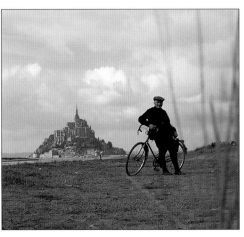

◄ Picture postcard
Travel pictures rely heavily on a romantic image to attract holiday-makers. Here, a stereotypical Frenchman on a bike has been cajoled into providing foreground interest in this shot of Mont St Michel, Brittany. 35–70mm, 1/30sec, f/8

▲ Young innocents
In this photograph, I wanted to show an idyllic scene where dreams of romance, peace and harmony prevailed. The composition gives prominence to the setting, relegating the figures to a secondary role but giving the imagination free rein to suggest the likely relationship. 80mm, 1/125sec, f/8

SIMPLE SETTINGS

Although elaborate settings, if they add information about, or are relevant to, the sitter, can be used to great effect in portraiture, so too can simple ones. Here, the viewer of the photograph is not being given any clues, but this can be compensated for by the fact that attention will be firmly directed to the subject.

MAINTAINING INTEREST

With so little to distract the viewer, you need to ensure that what is present is sufficient to warrant close scrutiny. Colour itself can have great pictorial appeal, as can shape, form and texture. But if you are working in black and white, your palette will consist of shades of grey, ranging from pure white to dense black. If rendered fully, however, they can still provide a visual feast.

In large interior rooms, you may well have to light the subject and the room separately, in order to bring out the texture in the walls. For accentuating the texture of stone, for example, sidelight is best – but this kind of lighting would not necessarily suit the subject.

The position of the camera is obviously vital to the success of your pictures. Even in a cluttered environment, adopting a high or low camera angle can help to throw your subject into sharp relief.

Differential focusing can also be useful; a small aperture can mean that even quite complicated backdrops can be turned into a simple abstract pattern of colours.

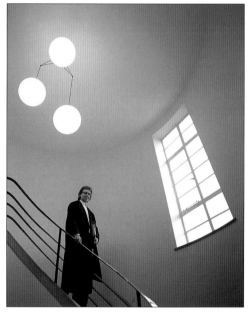

▲ Low camera angle
A low camera angle provides an interesting view of this staircase, exaggerating the curve of the rails and including the strong shapes of the lights. The mixed lighting adds a warm glow to the portrait..
35mm, 1/15sec, f/11

▶Lines of perspective
Here, I have used the parallel lines of the boards making up the floor and ceiling to give the picture a feeling of space. This has been further emphasized by using a wide-angle lens.
60mm, 1/60sec, f/16

▶High camera angle
For this shot, I wanted the viewer to perceive the isolation of the young child selling the potatoes from an old basin. I stood on my camera case and so framed her against the dark-coloured, plain-paved floor.
50mm, 1/250sec, f/11

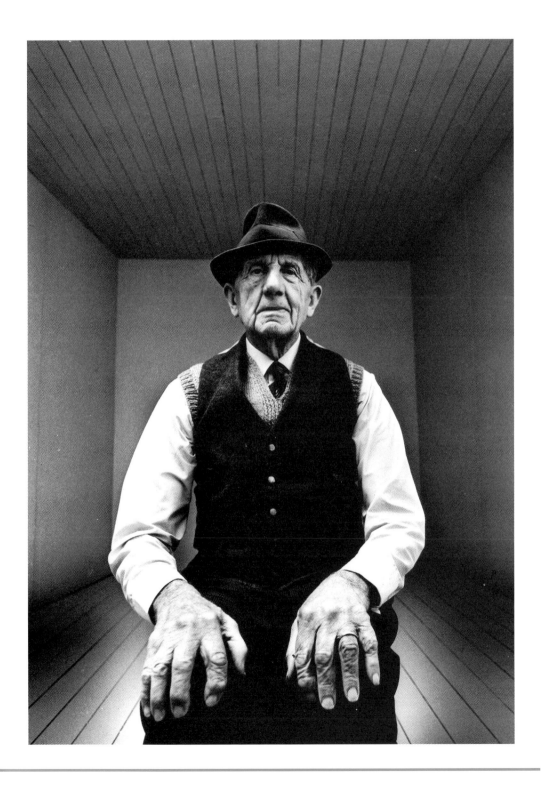

TRAVEL

Travelling to different parts of the world and even, to a lesser extent, to different parts of your own country, sharpens your awareness of your surroundings.

When you first arrive at a new location is the best time to start taking pictures, as it is when you will see and notice the unfamiliar most clearly; it is surprising how quickly the foreign sights, sounds and smells start to become commonplace.

BE PREPARED

Obviously when travelling you will not have access to your familiar photographic supplier, so make sure you have plenty of film. In most countries you will be able to purchase extra film, but in hot countries in particular the shelf life of photographic

▼ Local colour
Market and street traders provide a rich source of photographic subjects. Markets are often colourful places, full of vibrant characters. Spend some time looking around the market with your camera ready, returning to those stalls that are especially colourful and interesting. Take overall shots at the same time to give context to the portraits.
80mm, 1/125sec, f/5.6

▶ Sitting pretty
Camel drivers are always happy to pose for tourists' cameras. Here, the interesting shape of the camel adds another dimension to the photograph. When including large animals in portraits, decide whether it is the animal that you wish to focus on.
85mm, 1/60sec, f/5.6

▲ Stranger than fiction
Some of the sights that you see whilst travelling defy description. It is therefore essential that you carry around your camera whenever possible so that you can show the bizarre characters and their strange apparel to others.
35–70mm, 1/125sec, f/8

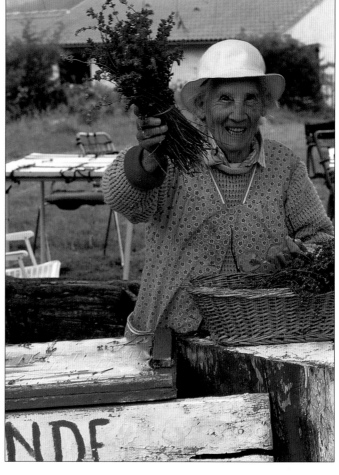

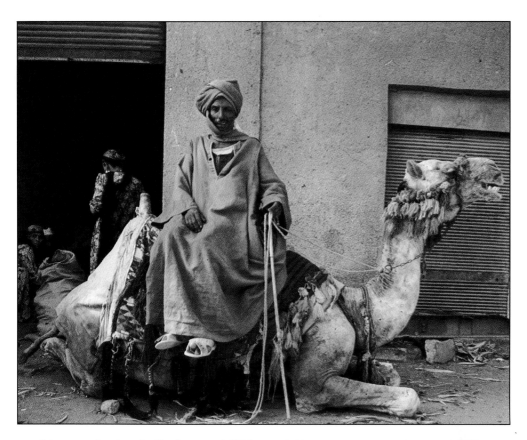

emulsions can be drastically shortened. With this in mind, if possible store unused film in a refrigerator (not the freezer) but make sure you allow a few hours for it to come up to room temperature before loading it into the camera.

SLR users must consider very carefully how much equipment they want to carry around with them when they are on holiday. There is a temptation to take everything – just in case. But it might be better to travel light, with the bare minimum of equipment. A couple of zooms, for instance, can cover all the most used focal lengths from 28mm to 300mm, giving you scope for candid shots and panoramic backgrounds.

A portable flash unit with some type of diffuser is also very useful. A heavy tripod is often more trouble than it's worth, but a small tabletop version, which fits discreetly in a bag, will give you the flexibility to use long shutter speeds when required.

▲ Willing subject
It is often worth asking people to pose, giving you more time than if shooting a candid snap.

This Italian woman was obviously proud of her motor scooter and was pleased to pose.
50mm, 1/125sec, f/8

LIGHTING
TECHNIQUES

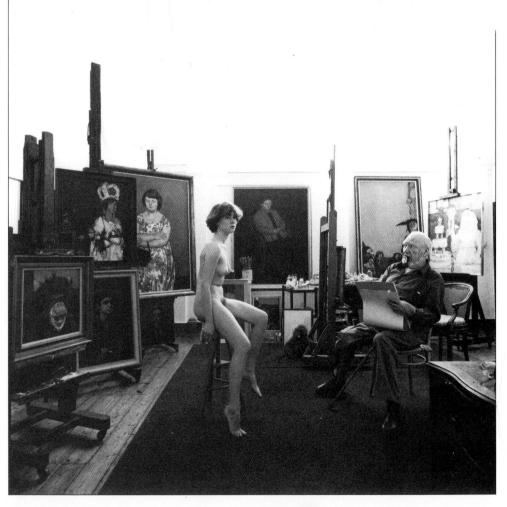

60mm, 1/60sec, f/16

LOW-LIGHT PORTRAITS

It is often tempting to reach for the flashgun as soon as the lighting level falls below a certain brightness. But resisting this can produce the most atmospheric portraits.

Low-light levels mean that the usual range of apertures and sensible shutter speeds are not available. But there are ways round this problem. Faster lenses and faster films can be used, and as long as your subject is still, you can use a tripod so as to extend the usual range of shutter speeds.

One of the greatest problems with low light is that of contrast. Small light sources increase the brightness between shadow and highlight areas to extremes. When contrast is too high for the film to cope with, you will need to decide whether to expose for the highlights and allow the shadows to go solid, or to expose for the shadows and allow the highlights to burn out. Some film types are more tolerant than others, however.

FAST LENSES

In dim conditions you really appreciate a traditional standard lens. For 35mm photographers, the 50mm lens is one of the cheapest to buy, yet will be noticeably 'faster' than any other lens they own, and their zooms in particular.

In other words, the 50mm will have the largest aperture, usually ranging between f/2 and f/1.2. The difference between f/1.4 and the f/2.8 setting on a longer lens, for example, might not sound very great, but f/1.4 will transmit four times as much light.

In practical terms this means that with an SLR, where you use the light coming in through the lens to view the image, the image seen through an f/1.4 lens will be four times as bright on the focusing screen. It will also allow you to use the camera hand-held in dimmer light. A wide maximum aperture also gives an extremely shallow depth of field, which will throw distracting backgrounds completely out of focus.

FILM SPEED

When planning low-light portraiture another consideration is film speed; the faster the film, the less light it requires in order to produce an image.

Until recently, high-speed film (with ISO numbers higher than 400) produced a very coarse grain pattern. This, however, is no longer such a problem, since new films have been developed that have extreme sensitivity to light

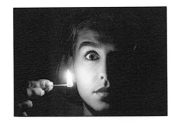

► **Matchlight**
This evocative portrait was taken by the light of a match. An ISO 200 slide film was pushed one stop.
50mm, 1/8sec, f/1.2

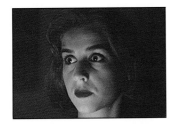

► **Oil lamp**
Because of the low-temperature light of the oil lamp, I used tungsten-balanced film here to avoid a picture that was too orange.
50mm, 1/30sec, f/2

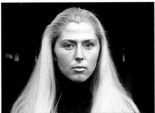

► **Fluorescent light**
Because of the spectrum emitted by fluorescent light, it is nearly impossible to obtain accurate colour pictures.
85mm, 1/15sec, f/4

► **Mixed light sources**
For this portrait I excluded most daylight and used a cluster of candles as the main illumination supplemented by four desk lamps, as shown in the diagram.
50mm, 1/15sec, f/4

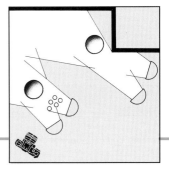

without grain being excessive. Super-fast ISO 1600 and 3200 films are now available and give very acceptable results.

It is also possible, even if you find yourself with too slow a film in the camera, to expose it as if it were faster. Every f/stop you under-expose, or push, the film equals an effective doubling of the ISO number. You will find information on the leaflet that accompanies your film, explaining the degree of under-exposure it will tolerate and any special processing methods that are necessary. But any increase in development time resulting from this may increase contrast.

When you expose film under unusual light sources, such as candles, oil lamps, fluores-cent tubes, and so on, you should not expect colour results to be faithful to the original. All colour film is formulated to produce particular colour results under very specific types of illumination.

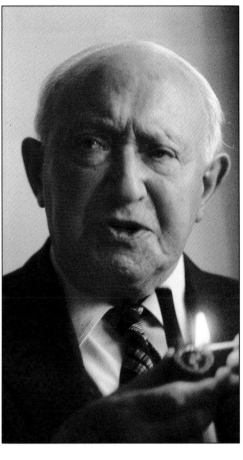

▶ **Morning light**
I took this shot of Manny Shinwell, who was a British Labour Party Member of Parliament from 1922 to 1970, in early morning light. The match added little or nothing to the light levels but it provided a very welcome highlight. 85mm, 1/30sec, f/2.8

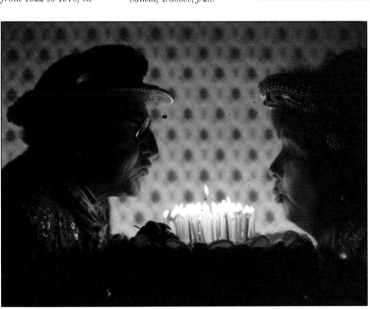

◀ **Reflective surfaces**
The buttons on the costumes of this Pearly King and Queen make wonderful reflective surfaces, acting as tiny beacons glowing out of the shadows. 50mm, 1/15sec, f/2.8

SILHOUETTES

Silhouettes concentrate attention on the outline and shape of a subject alone, and help to destroy the illusion of reality created by photographs. Shooting silhouettes is not difficult and involves taking advantage of a situation photographers are often warned that they should avoid – that of high-contrast lighting. In fact, the greater the difference between the highlights and the shadows, the stronger the silhouette.

It also means breaking another related 'rule': that you should always keep the sun behind you when taking pictures. Here, you need to do the exact opposite, because shooting into the light will ensure that anything positioned between the camera and the light source is rendered in outline only. Remember to take your light reading from the light source, though, and do not increase exposure to compensate for the subject. Even with fully automatic cameras, all you need do is position yourself correctly in relation to the light source and remember not to press the backlight-compensation button before taking the picture.

▶**Skylight**
A perfectly exposed sky has thrown this girl's profile into high relief. There was, in fact, a four-stop difference between light readings taken from the sky and a close-up reading taken from the face – ample to create a silhouette. 85mm, 1/250sec, f/8

▶ High-contrast printing
More detail exists in the negative of this picture than appears here on the page. In order to strengthen the silhouette effect, I used a high-grade printing paper to remove many of the grey half-tones and create more of a graphic impression. 120mm, 1/125sec, f/5.6

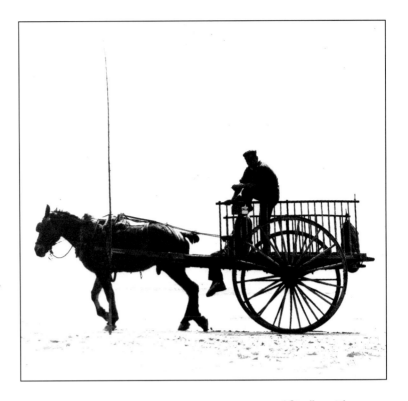

◀ Window light
Bright daylight streaming through the workshop window has strengthened this scene, changing it into a study dominated by shape and outline only. 50mm, 1/125sec, f/11

◀ Studio setting
Silhouettes in the studio do not present any problems. Set your lights so that only the background is illuminated and then take an exposure reading from the highlights. 80mm, 1/60sec, f/8

HIGH-CONTRAST LIGHTING

Knowing exactly the exposure latitude of your film (the range of tones it is capable of recording between dense black and pure white) is a matter of experience and trial and error. So, too, is the ability to recognize situations that might push your film beyond its recording capabilities. High-contrast lighting is the most common situation; the fact that you cannot expose correctly for shadows and highlights simultaneously can make for problems. But sometimes, as with silhouettes, it produces rewards.

Shooting in high-contrast lighting is an easy way to introduce drama and interest to your pictures. If contrast is too high for the film and you don't want to create a full silhouette, you may have to use a weaker, supplementary light on the shadow side of your subject. If this is not possible, then a simple white cardboard reflector or length of kitchen foil will reflect back sufficient light to provide a little modelling.

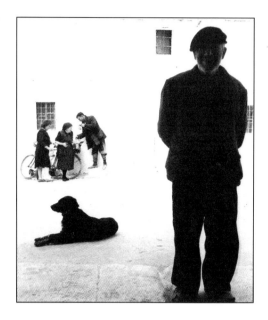

▶ Selective light reading

In situations such as this, where you cannot hold exposure for both the highlights and the shadows, you need to make a decision about which elements are most important for the shot. Here, I took a spot reading from the man's face and set the camera controls accordingly. 50mm, 1/60sec, f/4

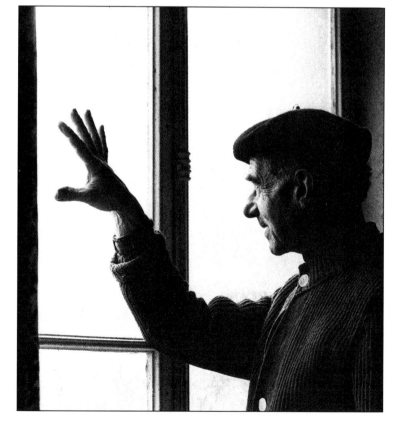

◀ Balancing tones
Although the shadowy foreground figure takes up only a small part of the frame, he balances perfectly the much larger area of sun-bleached white. The dark tones act almost like stepping stones, taking the eye progressively deeper into the picture.
50mm, 1/250sec, f/8

▼ Royal profile
For this picture of Her Majesty Queen Elizabeth II a single floodlight was used to light the face, while a low-power spot threw just a little illumination on to the neck. To keep the background completely black, you need a good separation between it and your subject so that reflected light can not bounce onto the backdrop.
80mm, 1/125sec, f/4

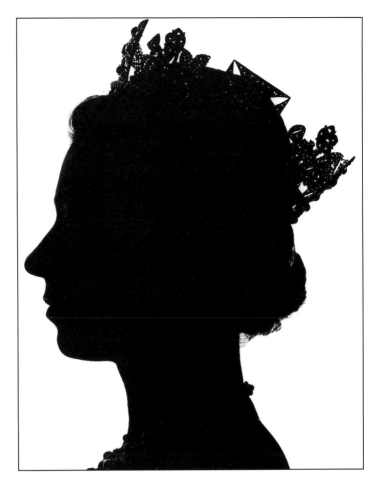

▲ Stamp of approval
This picture shows what can be achieved with a few simple studio lights. For the full silhouette, (top of page, and on the stamp) I positioned the subject against a window and exposed for the highlights, making sure that the tones would be even throughout.
80mm, 1/125sec, f/5.6

FLASH LIGHTING

◀ **Before and after**
For the shot far left, I took an exposure reading from the sky and set the camera controls that produced a silhouette. For the second shot, I kept the camera controls the same and used camera-mounted flash to fill in subject detail.
28mm, 1/125sec, f/5.6

▶ **Dominant flash**
It was night when I set up this shot, and the real difficulty was choosing the precise moment to press the shutter, even *though I had marked a spot for sharp focus beforehand. Capturing the relevant action was still a matter of luck.*
50mm, x-sync, f/4

Electronic flash is a more versatile lighting medium than many people give it credit for. Even quite physically small units are capable of providing sufficient light to expose correctly the interior of most normal-sized rooms, taking into account the colour, and therefore the reflective qualities, of the walls and ceiling. The built-in sensor (in the camera or in the flashgun) will also allow you to bounce the light – off the ceiling for example, or off a special flash umbrella – to produce a softer, more diffused, lighting, while still ensuring that there is enough light output to do the job.

But instead of letting flash become the dominant source of light, you can also use it in a supplementary, or fill-in, role.

Although when using a 35mm SLR you have to set the camera's shutter speed to a specific synchronization speed (usually 1/125sec or longer), bear in mind that it is the duration of the flash of light that determines exposure. Even with basic units, this can be as short as 1/30,000sec. This allows you to freeze moving subjects in low light.

▶ **Action stopping**
This is another shot from the series above. For this picture I asked the model to jump up and down so that her hair would really fly away. The *action-stopping flash has practically frozen all movement. A faint after-image remains created by the ambient light and the shutter exposure.*
85mm, 1/125sec, f/5.6

HIGH AND LOW KEY

Undeniably, tone and colour affect the way we regard photographs and influence our feelings toward the people or scenes depicted in portrait photography. An often-used technique is to restrict the tonal or colour ranges contained in pictures in order to accentuate a particular atmosphere and thus manipulate the mood of the shot.

LOW-KEY LIGHTING

This type of lighting scheme consists of dark tones or colours. The lighting technique is often used to imply strength and masculinity, but you should take this as a guideline only, because as you can see from the picture below, it can also be used to just as good an effect with female subjects to produce a sense of mystery.

Creating a low-key effect in the studio is relatively straightforward. You can use any point source of light: candle, desk lamp, naked bulb, or the narrow beam of a spotlight, masked down even further if necessary, but not the more uncontrollable spread of light from a floodlight. If the density of shadows created by these types

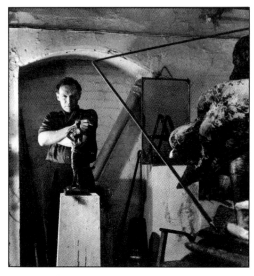

▲ Available light
Often, when working indoors without artificial light, pictures tending toward low key *are forced on you – otherwise, people's faces appear over-exposed.*
50mm, 1/30sec, f/4

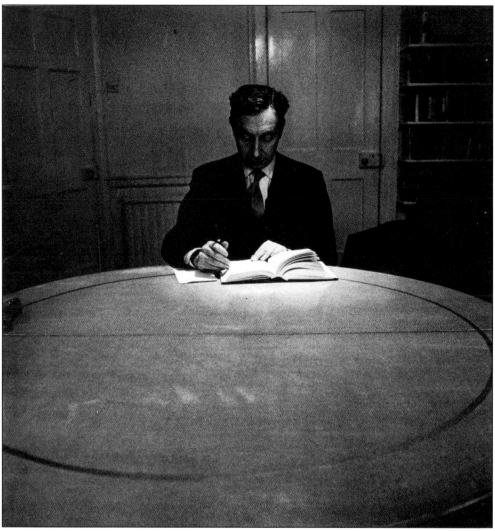

◀ Breaking with tradition

This shot goes to prove that low-key lighting can be used to good effect with either male or female subjects. I made sure that just enough of the model's face could be seen in order to intrigue and tantalize the viewer. Lighting was not complicated, and was provided by an ordinary domestic table lamp held a few feet away from the model's face. If reflections from the setting cause problems, surround the model with dark cloth.
85mm, 1/15sec, f/2.8

▲ Unusual highlight

With this portrait, taken in the study of the philosopher A. J. Ayer, I did not have the option of using flash. Instead, I had to rely on the ordinary tungsten-balanced room lights. Working in my favour, however, was that the overhead bulb lighting bounced off the pages of the open book, acting like a miniature reflector and throwing sufficient light on to the face to give an unusual highlight on the subject's face. Another consideration was the composition. I particularly wanted to use the large expanse of the round table as a foreground, because it created such a nice shape; I therefore had to use a small aperture to ensure an adequate depth of field.
50mm, 1/30sec, f/8

HIGH AND LOW KEY

of arrangement is not sufficient to kill most extraneous detail, then you will have to use black background paper as well.

HIGH-KEY LIGHTING

This describes an effect where you eliminate nearly all shadows and create a photograph with light tone or coloration, as in the examples shown below and opposite. Usually, high-key lighting is applied to female subjects, but you can easily see in the examples shown here how the removal of many of the darker, contrasting tones produces a light, airy atmosphere.

To create high-key lighting in the studio you must surround your model with soft light sources, further diffused with tracing paper, so that shadows do not form. Any that do can be filled in with reflectors. Use a light or white, background paper or setting. In the less-controllable light outdoors, you need a bright, overcast day when contrast is naturally flat. You then overexpose the shot by metering for the darker tones.

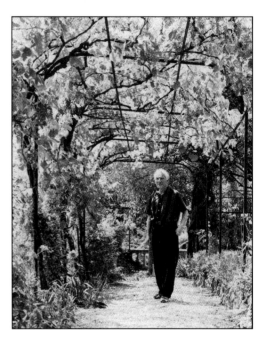

▲ **Dappled light**
Take advantage of natural conditions in order to create high-key effects. Here, in this picture of the painter Marc Chagall, bright sunlight filtering through the foliage and reflecting back from the pathway helped spread and diffuse a soft light into many of the shadow areas.
50mm, 1/125sec, f/8

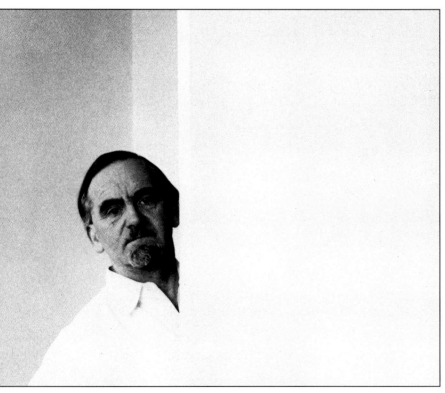

◀ **White background**
For this photograph of the painter William Scott, I used the strong sunlight to produce a light, airy, high-key effect. Light reflecting back from the wall behind, and the light-toned shirt worn by the subject ensured that very little shadow was left unfilled.
85mm, 1/250sec, f/16

▲ Misty conditions
Obtaining the correct exposure is always tricky in misty light conditions, since the meter tends to see more light than there really is. It is therefore a good idea to bracket exposure in these conditions. Another feature of mist is that it spreads light and therefore reduces contrast – ideal for a high-key effect. These conditions were perfect for this milkman with his hand-cart, taken in the 1950s.
150mm, 1/60sec, f/5.6

DEVELOPING
A STYLE

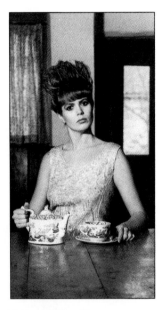

50mm, 1/125sec, f/8

1/60sec, f/11

50mm, 1/60sec, f/8

35mm, 1/60sec, f/5.6

35mm, 1/60sec, f/8

80mm, 1/60sec, f/11

IMPLIED RELATIONSHIPS

Proximity, or even a chance visual alignment, can be enough to imply a relationship between people in a photograph. More often, though, the expression and physical attitude of the subjects act as guidelines to people within a frame, and to capture these requires alertness and quick reflexes.

When you look at the pictures on these two pages, it is possible to see that in each case the shutter has been pressed at just such a significant moment as that described above. Each one encapsulates a relationship, which might have existed only for a few brief moments, but is nevertheless wonderful material for the camera. It is worth noting, that some of the subjects were conscious of the camera and this fact has added to the expressiveness of the images.

▲ Touching couple
The physical proximity of people to each other tells you a lot about their relationship. Although this shot is posed, the fact that the two girls are touching shows a great friendship exists between them.
35–70mm, 1/125sec, f/4

◄ Contrasting characters
The camera is marvellous at revealing facial expressions that would otherwise be too fleeting to register. Here, the contrast between the animated expression of the boy and the passive look of the girl creates a fascinating image.
35–70mm, 1/250sec, f/5.6

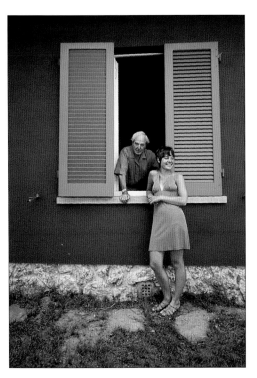

▲ Close relationship
Simply by including two people in the same shot, you can imply that a relationship of some sort exists between them. The *closely-linked pose, naturally adopted in this shot by Henry Moore and his daughter, Mary, reflects their relationship.*
35–70mm, 1/125sec, f/5.6

▲ Cycling couple
A shared prop or similar clothes helps to reinforce the bond that exists between two people in a picture. The fact that *both the subjects in this photograph are on bicycles makes the viewer more sure that the two are connected.*
35–70mm, 1/60sec, f/5.6

◄ Family groups
We are so used to seeing formal group pictures of schools, clubs and families, that we assume a relationship. In this family portrait, I have broken with usual photographic tradition by using differential focus, so that only the father is sharp in the frame.
90mm, 1/125sec, f/2.8

CLOSE RELATIONSHIPS

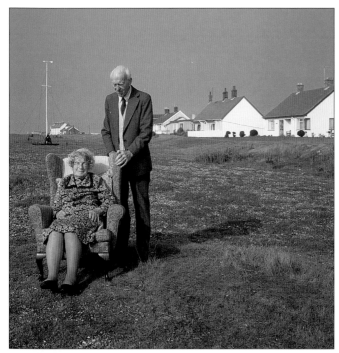

◄ A knowing look
The way in which the man cradles the chair and looks down at his wife gives a suggestion as to their long relationship.
80mm, 1/125sec, f/11

► Family resemblance
Placing a mother and daughter side-by-side in close-up allows you to analyze the family resemblance.
90mm, 1/250sec, f/5.6

▼ Father and daughter
Capturing parents cradling young children in their arms, or carrying them on their shoulders, allows you to see the very close bond that exists between father and child, or mother and child.
200mm, 1/250sec, f/5.6

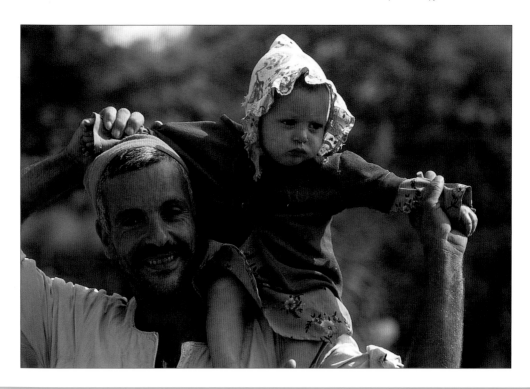

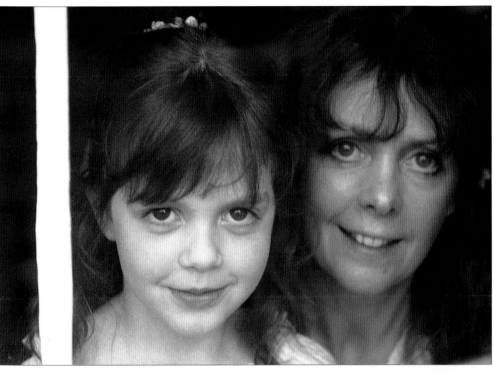

▼ Leading the eye
In this husband-and-wife portrait, the woman appears very small within the frame. However, the garden path leads the viewer through the picture, past the husband with his watering can, to the onlooking wife standing by the back door.
80mm, 1/125sec, f/11

▲ Doorways
Doorways and windows make great natural frames for family groups. Not only do they act as a compositional device, but the added detail shows us something about the family home.
35–70mm, 1/125sec, f/5.6

115

A SENSE OF SCALE

All too often, the reaction of people on seeing the latest photographs they have taken is that they do not portray the scene they remembered. Human eyesight is selective: it is capable of increasing the apparent size and importance of elements it concentrates on and decreasing those that it considers less so. The camera lens is also capable of changing the scale of objects it records, but in a far less discriminatory manner, sometimes giving importance to objects you hardly noticed at the time.

MANIPULATING SCALE

A person does not need to loom large in a photograph in order to acquire importance, as you can see in the photograph below, where a figure occupying a relatively small area of the frame is able to hold his own against the grandeur of a towering, marble fireplace. The apparent scale of any object is affected by many things, including framing, strength of tone, colour contrast or harmony, camera position, and the lens used.

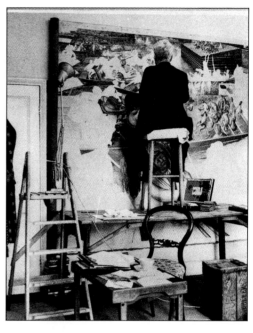

▲ **Precarious perch**
To indicate the size of the canvas, and thereby give a sense of scale, I moved back from the subject as far as possible and used a wide-angle lens. This way, I could show the setting and the arrangement of supports needed to give access to the painting.
35mm, 1/60sec, f/8

◄ **Overwhelming proportions**
Tonal contrast in this picture of Lord Howard, shot in the hallway of Castle Howard, helps prevent the figure from becoming absorbed in the massive fireplace behind.
60mm, 1/50sec, f/16

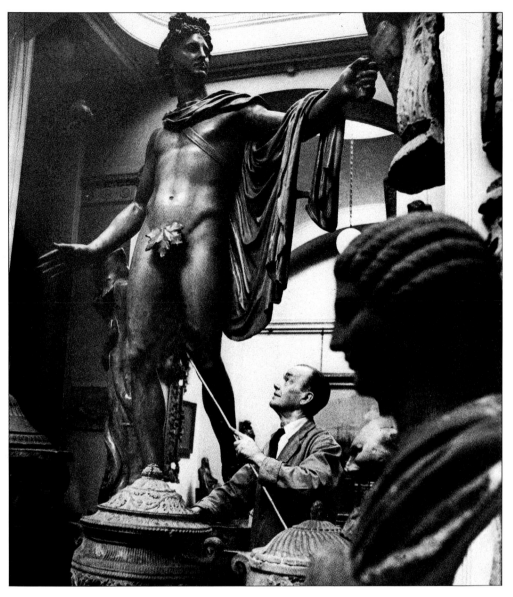

▲ Camera angle
Wanting to emphasize the towering presence of the statues, I used the cleaner both as an indicator of scale and human life amongst all the stone. If you can introduce humour, through shape or pose, so much the better. 28mm, 1/30sec, f/11

A useful exercise is to look back through your stock of photographs and take note of why certain parts of compositions seem dominant. Perhaps it is because you have included a small area of strongly contrasting colour or tone, or because you have positioned your subject in a strategically important part of the frame. It could be that you have brought a figure forward in the frame by using a telephoto lens or caused distracting or secondary elements to recede by using a wide-angle lens.

117

PROPS

There is no good reason to feel that portraits need to be shots of figures in isolation. If you can help your subjects to relax, or reveal something about them as people, by allowing them to pose in certain settings or use other props, such as newspapers, musical instruments and so on, then so much the better.

Photographs that pose questions for the viewer are far more likely to sustain interest for longer than completely straight portraits. Bear in mind, though, that the prop should act in a subsidiary role only, and not deflect attention too strongly from the subjects of the photographs themselves.

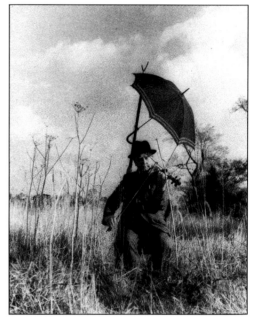

◀ Masthead
For this portrait of former Tribune *editor Dingle Foot, I had him pose with the left-wing newspaper he was associated with.*
80mm, 1/30sec, f/8

▲ Unusual venue
This retired musician still practised every day, – but he did this in the garden so that his wife could get on with cleaning their small cottage in peace!
85mm, 1/125sec, f/11

▶ Set on a pedestal
For this shot of Henry Moore, I placed him on a pedestal instead of one of his sculptures. Although I took this picture as a joke, the Henry Moore Foundation used it on a poster for an exhibition.
60mm, 1/60sec, f/4

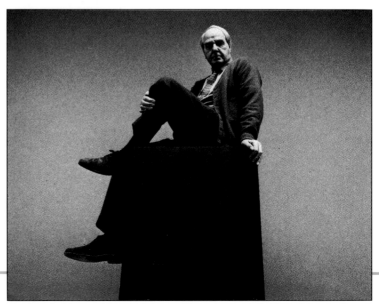

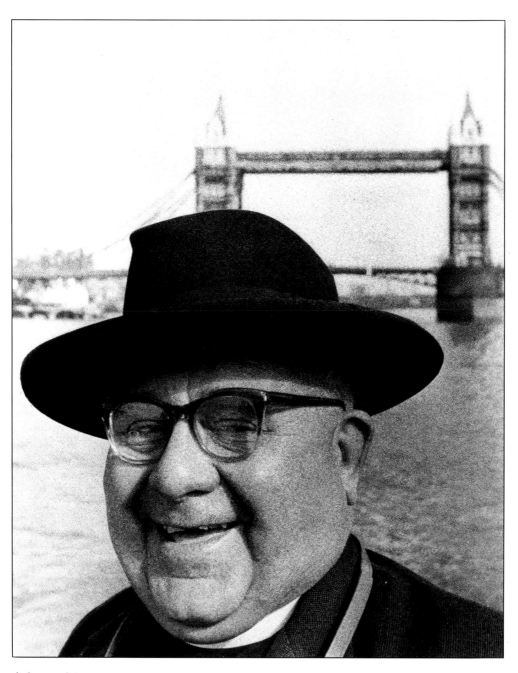

▲ Appropriate background
This gentleman kept many of his fellow passengers amused on a Thames riverboat with his anecdotes. I tried to

capture his lively and extrovert personality as well as the imposing background, with London's Tower Bridge straddling the river.
1/125sec, f/16

CHILDREN

Along with vacations and other special family occasions, children are undoubtedly one of the most photographed subjects. All parents would regret not having a pictorial record of their children as they grow up and, because development is rapid, especially in the first few years, many pictures are likely to be taken.

Older children are fast on their feet, subject to rapid changes of mood and attitude, and, in most cases, quite prepared to forget about the camera and simply get on with whatever it is they are doing. Allowing them to do this, without getting them to pose, often allows you to get the most natural pictures. As with taking portraits of any type of subject, your work will have additional impact if it contains more than a simple likeness. Composition, background, tonal contrasts, colour combinations, environment, and so on, are all factors you need to take into account. Do not, however, let technique get in the way – quick reactions are vital. Often it is better to have a record picture than none at all.

▲ Playtime
*Children get very absorbed in what they are doing. So if they are occupied you will be able to take pictures of them looking natural, without them even noticing the camera.
35–70mm, 1/250sec, f/5.6*

◄ Let babies lie
*As young babies can not sit up on their own, it is difficult to photograph them without their poses looking awkward. One of the best ways round this is to lie the child down, and then shoot from directly overhead.
35–70mm, 1/60sec, f/4*

◄ Choosing camera height
As children are generally shorter than the photographer, they often end up being photographed from a high camera angle. By looking down on them, children look smaller and more fragile. For a more natural-looking photograph, however, it is worth kneeling down so as to shoot from their eye level.
35–70mm, 1/125sec, f/5.6

▼ Body language
In this photograph we might not be able to see the boy's face clearly, but with the shape of his body outlined against the white backdrop of snow we can still see the effort involved in trudging back with the toboggan.
35–70mm, 1/125 sec, f/4

MOVEMENT

With most modern cameras, stopping, or freezing, the motion of cars, running figures or pieces of machinery is no problem – on even basic 35mm SLRs, for example, it is not unusual to find a shutter speed of 1/2000sec or faster. Often, though, you can add dramatically to the impact of a photograph by choosing a slower shutter speed that does record some movement while freezing other parts. Recording movement works best on light-toned subjects or when there are strong highlights in the picture: these tend to spread and 'eat into' darker, shadowy areas of the scene.

Another way to record motion is to move in parallel with, for example, a figure on a roundabout, as in the example opposite, and use a shutter speed that blurs the stationary background while recording a relatively clear picture of the subject.

◄ ▲ Angle of view
These two pictures demonstrate that the angle of the camera in relation to the direction of travel of the moving figure or object is important to the way it is recorded. Both shots were taken at a shutter speed of 1/125sec, but in the version above I stood so that the hand-cranked spindles were moving directly toward and away from me as they spun. The result is that they appear motionless. In the version left, spindles being turned at about the same speed were moving across the field of view of the camera, and they have recorded as a continuous blur.
Both shots: 50mm, 1/125sec, f/8

▶ **Cartwheels**

*To have frozen the move-
ment of this figure would
have been easy, but the
result would have looked
unnatural. The hint of
movement adds vitality
to the shot.*
50mm, 1/125sec, f/8

▼ **Roundabout**

*With this shot, I
combined a slow shutter
speed with flash, as I
span round on the play-
ground ride with the
subject. The background
appears blurred, whilst
the subject is frozen.*
50mm, 1/30sec, f/4

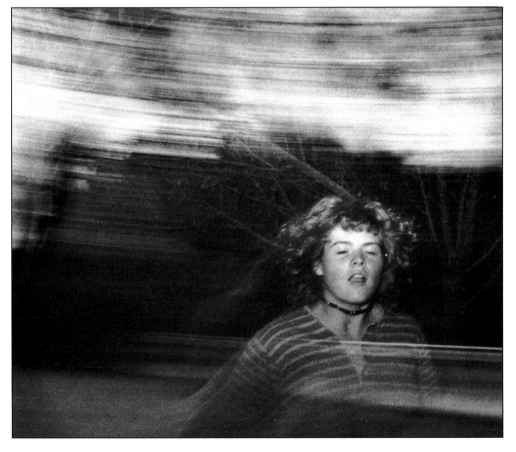

THE STRENGTH OF PATTERN

The challenge for the photographer is always to endeavour to find a new approach to his or her portraiture. To produce a varied and interesting portfolio is an exciting prospect and potentially a very rewarding one.

Taking photographs that show people relating to their environment or to other people are two of the main ways to communicate more in your portraits. This approach broadens the scope of your work tremendously, informs the viewer about your subjects' backgrounds, and allows you to introduce other vital elements into your work – such as perspective, framing, atmosphere, and, very importantly, pattern.

Perspective can have a great effect on the way pattern is perceived – by increasing subject distance, and using a telephoto lens, patterned backdrops can appear much closer to your subject, filling the frame. Alternatively, a wide-angle lens can allow you to exaggerate the size of a pattern that is in the foreground.

Look out, too, for the pattern created by shadows. Window blinds, for instance, can create a wonderful striped pattern over all the elements within a scene. The smaller shadows of leaves, meanwhile, can create dappled light, casting a myriad of highlights over a person's face.

▼ Silhouette
The pattern created by this human pyramid relies on information about shape, rather than form or colour. By deliberately choosing a low camera angle to position the group against the bright sky, I was able to create a silhouette, showing this shape alone.
70–210mm, 1/500sec, f/8

▶ Brolly backdrop
An umbrella is an extremely useful tool for portraits. Not only does it protect the subject from the rain and bright sun, but it can add colour and pattern to the picture. Notice how the lines of the umbrella draw the eye into the centre of the picture and to the subject's face.
35–70mm, 1/125sec, f/4

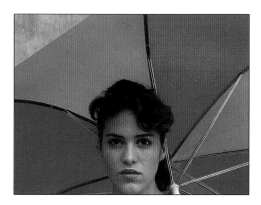

▲ Repeating pattern
Clothes, of course, are often heavily patterned. For this shot I deliberately sought out a striped backdrop that I could use to match the hooped jumper and trousers of the model. *90mm, 1/250sec, f/8*

▲ Mixing patterns
Sometimes you can get away with superimposing conflicting patterns in a shot. But, to restrict the stripes of the backdrop I used a long lens, so less of this pattern was included. *70–200mm, 1/125sec, f/8*

◄ In the shadows
The shadow of this fern creates a mask-like pattern across the face of the girl. The model had to move her head to exactly the right place, whilst lying down on the ground, to create the tiger-like face paint. 90mm, 1/250sec, f/8

USING WIDE-ANGLE LENSES

Used indoors or outdoors, the wide-angle lens can be invaluable. It is easy to see the more obvious optical characteristics wide-angles display, such as converging verticals, when the lens is pointed up at a subject. However, there is also something less tangible – a subtle shifting of perspective resulting in objects within the frame having apparently different relationships to each other. Objects in the foreground look disproportionately bigger than those further away from the camera. One of the benefits of working with an SLR is that you can see exactly how the image will finally appear. Use this facility by directing your subjects to pose in different areas covered by the lens.

▲ **Recognizable backdrop**
The shape of the Egyptian pyramids is so well-known that they did not need to appear large in my picture. Instead I used a wide-angle lens to include local colour to the foreground.
35mm, 1/125sec, f/4

◀ **Converging verticals**
The relative sizes of the girl and windows were vital here. A low camera angle makes the windows appear to converge – bringing the elements together perfectly.
28mm, 1/30sec, f/4

◀ **How much background?**
For this shot of a typical bazaar scene I could have used various lenses just by getting closer or further away from the group of men. If I had used a longer lens, however, the shot would have included less of the background. Using a 35mm lens, I have been able to include more of the faded wall with its muted colours.
35mm, 1/30sec, f/5.6

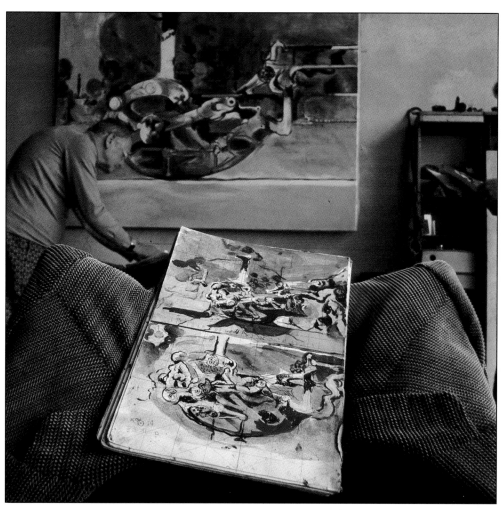

◀ Depth of field

Notice that although the man's grasping hand is only inches from the lens, its shape remains very recognizable, despite not being perfectly in focus. Sharpness improves rapidly as you follow the bend of his arm into the frame.
50mm, 1/60sec, f/16

▲ Showing relationships

Part of portraiture is showing something of your subject's life – interests or work, for example. Here, use of a wide-angle lens has drawn a powerful relationship between the artist Graham Sutherland and his paintings. It also conveys his method of working, progressing from sketches through to canvas.
60mm, 1/60sec, f/5.6

DETAIL IN PORTRAITS

There are good reasons to include isolated parts of your subjects' bodies as an element of portrait photography; not all pictures need to be instantly recognizable as a particular person in a specific setting.

When you start to explore parts of the body other than the face or full figure, you will find that the hands are usually the most revealing of character and personality. They can inform you at a glance whether the sitter has used his or her hands in some sort of manual occupation, for example, or whether they have led an entirely different sort of life. Even for commissioned portraiture this approach can be more imaginative than the usual head-and-shoulders shot.

▼ Informal attitude
In order to record the delicate skin texture of this model I used three reflected floodlights, so that the subject was lit with soft lighting.
150mm, 1/60sec, f/5.6

▶ Hands as frames
Isolated parts of the body can be startling, as in this shot of hands pulling back the edges of a sack to allow a face to peer out.
120mm, 1/125sec, f/2.8

LOOKING AT DETAIL

Once you have accepted the idea that portraits can be pictures of the body other than the face and that you will concentrate your attention on your subjects' hands, look at people when they are in conversation, at work, or involved in some other activity. The thing that immediately strikes you is that hands are very seldom still. People's hands are usually constantly on the move, fingers stabbing the air to emphasize a point, palms spread upward to invite a response, or grasping, gripping or finely adjusting some tool or piece of machinery. Even in repose, hands form beautiful shapes and at such times are particularly expressive of mood.

Focus closer on the hands and even more of the personality can be deduced. There are hands twisted and lined with the passing years that make the viewer of the photograph long to see their owner's face; hands soft and rounded, still not fully formed; hands perfect in their presentation; and hands used as vehicles for displaying ornamentation and revealing status.

▶ **Insight**
For this photograph of Henry Moore, I wanted his hands to say something about him and his work. I thought that his entwined fingers were reminiscent of the types of sculptures for which he was famous.
150mm, 1/60sec, f/4

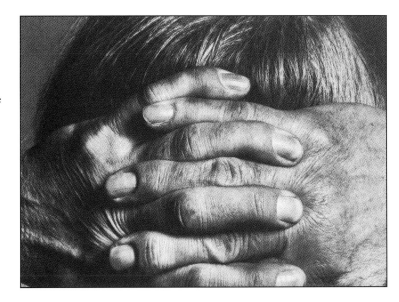

▼ **Sidelight for showing texture**
Daylight from the left provided superb modelling for these wrinkled, calloused hands.
85mm, 1/125sec, f/5.6

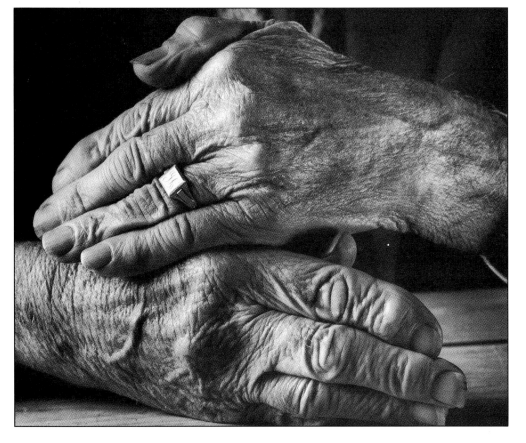

DETAIL IN PORTRAITS

▲ Showcase
When using hands as a showcase for a client's products, such as a range of jewellery and other accessories, then you must ensure that presentation is superb. The condition of the model's skin and nails must be completely faultless
– *the camera lens is far more critical than normal vision. For these two pictures (above left and right) I used diffused floodlights either side of the hands to minimize reflections from the shiny surfaces.*
80mm, 1/60sec, f/8

▼ The passing years
The hand of an old man gently cradles a photograph of himself taken nearly 90 years before in his wrinkled hands. Pictures such as this are priceless portrayals of the passing years.
135mm, 1/60sec, f/4

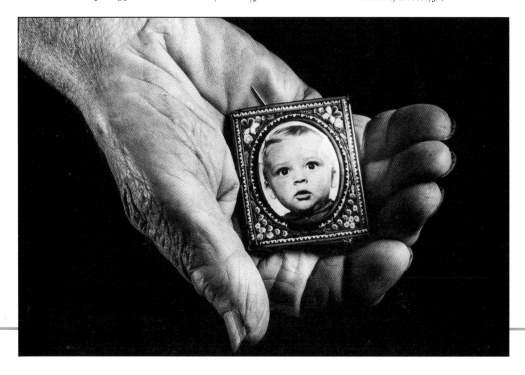

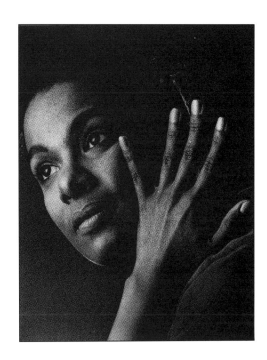

▼ Focusing attention

For the British sculptor Henry Moore, the significance of showing the hands in a portrait is more obvious, since it is the hands that are the focus of creative output. It is also a characteristic since he frequently used his hands this way to view his own work. 60mm, 1/125sec, f/8

▶ Balancing the composition

Do not concentrate on one aspect of a picture to the detriment of the rest. Here, the tilt of the model's head required her hand in shot to give the composition balance. The tension is such, the sides of the frame seem barely able to contain the two elements. 80mm, 1/30sec, f/4

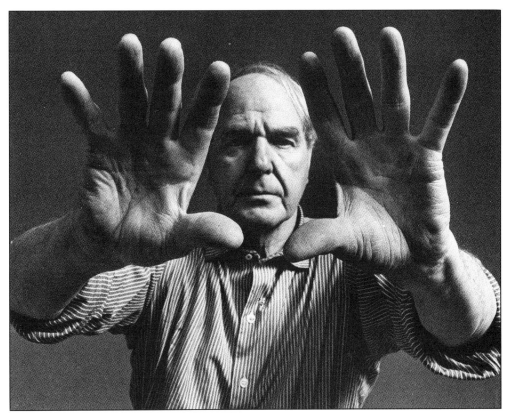

LEGS AND FEET

 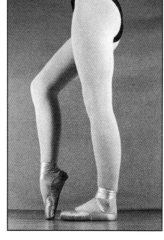 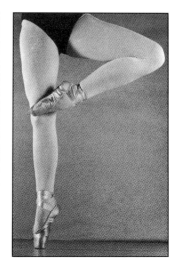

▲ Formal beauty
For this series of pictures, I wanted a completely neutral setting so that nothing would detract from the grace and beauty of the ballerina's legs. A plain grey background paper, one floodlight, and a series of cardboard *reflectors were sufficient to create a formal composition where there was just enough shadow to provide essential modelling, revealing the three-dimensional form of the legs. All pictures above: 85mm, 1/125sec, f/5.6*

▼ Manipulating attention
Posing the model on the flagstone floor emphasizes her nakedness. A carefully placed spotlight then produces an unexpected highlight. 50mm, 1/60sec, f/8

▶ Focusing on feet
Seen in isolation, feet take on an almost abstract, sculptural quality. Lighting for this shot was simple window light from the right. 135mm, 1/125, f/4

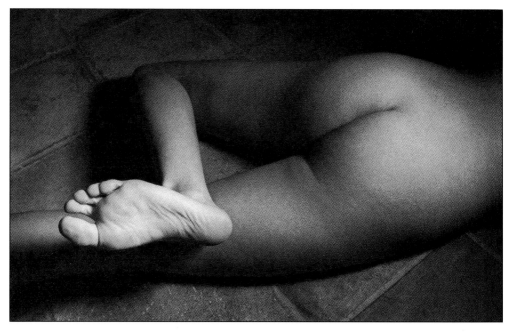

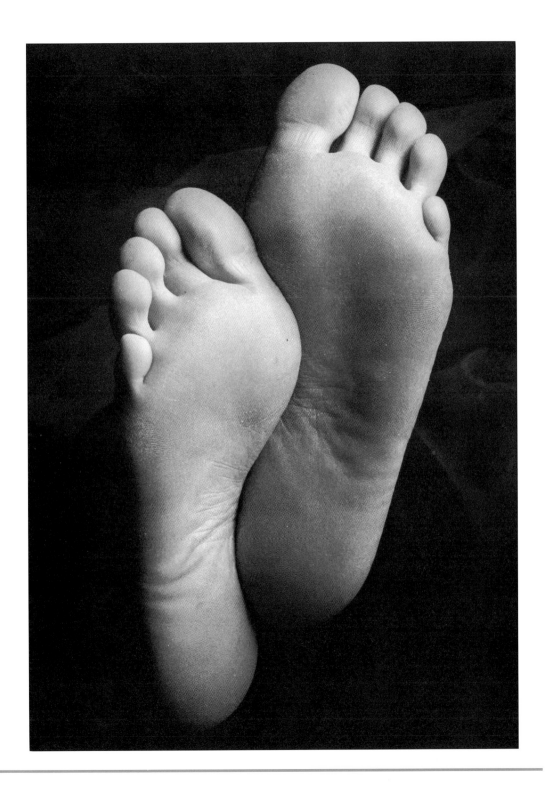

HATS

In portrait photography, choosing the right hat for your model can make a huge difference to your results. If you frame your shots tightly you can impart greater impact to the picture, by making use of vibrant and eye-catching colour. Also, of course, by framing tightly you do not have to concern yourself with how the model is dressed.

It is not possible to give specific advice on the type of lighting to use because so much depends on the style of hat, the shape of the model's face, and so on. But by using angled lighting, not only from the sides but also from above or below, you should avoid the lighting becoming too flat and uninteresting.

In general you will find that pictorial elements, such as colour, shape, texture and form, become more pronounced with a soft, directional illumination, although, on occasion, a strong spotlight will help to abstract shape, accentuate expression, and simplify an unnecessarily intrusive background. If shadows then become a problem, use reflectors under the face.

As soon as you pull the camera back a little, you also need to take into account the colours and style of the model's clothes. Colours can either coordinate or contrast, depending on the effect you are trying to achieve. But you must ensure that the style of hat and that of the clothes work together so that you do not end up with an elegant face and hat coupled with casual clothes. This advice holds good for most pictures, but there is no reason why you should not introduce a sense of incongruity on occasion.

The use of make-up is another factor that can make your work stand out. Use lipstick, eye-shadow and blusher colour to help link the hat with the face and clothes.

DULLING REFLECTIONS

If you decorate the hat with, for example, highly reflective jewellery, you must be careful to avoid creating bright highlights which will flare into the camera lens and spoil the shot. The angle of the lights is the determining factor here, but if these 'hot spots' prove impossible to avoid, you can spray the jewellery with special 'dulling' spray to reduce the amount of light that is reflected back.

◀ **Stressing shape**
By using an elevated camera position, the picture has become less a portrait and more of a study of shape and colour. I used one studio light below directed at the face, whilst a second flash was reflected to light the rim of the hat. 80mm, 1/60sec, f/8

▶ **Sun struck**
In bright sunlight, hats can be used to avoid harsh shadows under the eyes and nose of your subject. A reflector can be used to bounce back light into the face, if there is not enough indirect ambient light. 50mm, 1/250sec, f/5.6

▲ **Splash of colour**
One of the main reasons for using a hat is to add a splash of vibrant colour to a close-up portrait. Bright colours attract the eye, with red having the most impact. As the hat creates a frame around the model's head, however, the colour does not detract from the subject. Here, I used soft-box diffusers over lights positioned either side of the model.
80mm, 1/60sec, f/8

▲ **Complementary fashions**
The hat that you choose should match that of the the clothes the model is wearing – not only in colour, but also in style. This elaborate example of the milliner's craft combined with the elegant evening dress, complements the hat perfectly.
80mm, 1/60sec, f/8

REFLECTIONS

Reflections, especially those cast by mirrors, are often used by photographers in order to produce a different slant and a more imaginative type of portrait. For the effect to work, however, you must ensure that the glass surface is completely clean. Lighting such a picture is no different to taking the subject straight, but you do need to consider changing your focus and aperture settings – as well as avoiding the lights themselves appearing as reflections.

When both the subject and his or her reflection are to be in shot, and you want them equally sharp, then you need to select an aperture that will give you an appropriate depth of field. Bear in mind that if the subject is 3 feet (1m) in front of the mirror, then the reflection will be 6 feet (2m) from the subject. If you are including the reflection only, then focus the camera not on the surface of the mirror but on the reflection itself. This is an ideal technique to use for taking self-portraits, especially if you do not have a self-timer, or if you want a shot that includes your favourite camera.

▶ **Lead-in line**
This is a simple, but extremely effective, way of using a mirror to create a portrait. The approach gains additional impact as the model's arm creates a lead-in line, guiding the eye to the face against a plain background.
35mm, 1/60sec, f/11

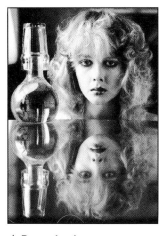

▲ **Repeating images**
The highly-polished surface of a table top makes an ideal reflector for this symmetrical double-image portrait.
50mm, 1/60sec, f/8

▲ **In the frame**
You can crop out the subject – here, by including only the reflected image, the mirror is transformed into a picture frame.
85mm, 1/125sec, f/11

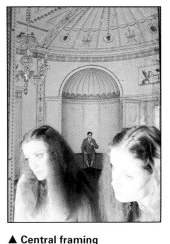

▲ **Central framing**
Here, I used a mirror to provide a double image of the girl, whilst a reflection of her father appears in the background.
28mm, 1/60sec, f/16

◀ **Selective focus**
Choose whether to focus on the subject or the reflection – at least one of them should appear sharp.
35mm, 1/125sec, f/2.8

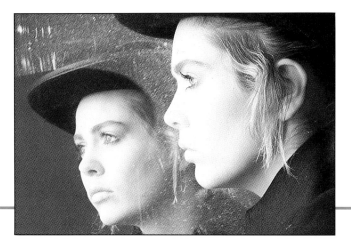

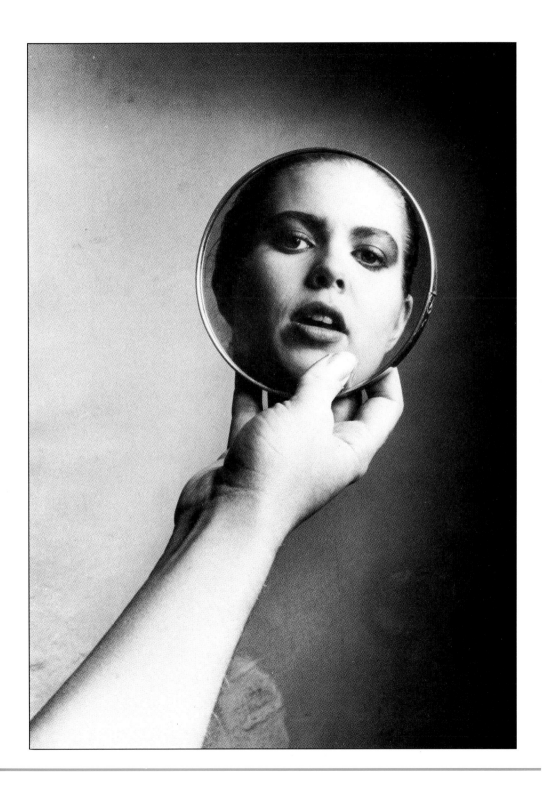

MASKS

Using theatrical props, such as masks, presents an ideal opportunity to experiment with more creative styles of make-up, costumes, settings and unusual lighting schemes – as well as being good fun for subject and photographer alike. Carnivals present good opportunities for ideas.

Many photographers, both amateur and professional, find that once the model slips on an identity-revealing mask it becomes easier to direct him or her into a variety of poses, as it breaks psychological barriers. Since the situation you are trying to record is unreal, you can afford to be a little more extravagant in your approach and aim to produce a dramatic impact on the viewer.

You will discover that pictures work better if you allow your model the freedom to move round the set. You are after a different result now than in straight portraiture, and so you must adapt your technique accordingly. Rather than setting lights for a very general, overall effect, try instead for a more selective lighting scheme, relying more on spotlights than on floods.

Use the qualities of the mask itself to dictate the type of picture you take – in particular, complementing its colour and shape by your choice of backdrop. Scary Halloween masks obviously suit dramatic lighting, while sophisticated ball masks can benefit from soft lighting and focusing.

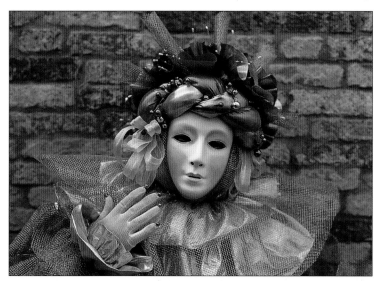

▶ **Primary colours**
Using theatrical props allows you to incorporate bright colours into your pictures which will immediately catch the eye of the viewer. Reds, in particular, tend to jump out.
35–70mm, 1/125sec, f/4

◀ **Backdrops**
It was impossible to use a wide aperture for this shot as the subject was in a narrow alleyway. The brick backdrop blends successfully with the costume.
35–70mm, 1/60sec, f/2.8

▶ **Using the sky as a backdrop**
To capture the intricate detail of the wing-like structures around these carnival-goers heads, I needed a plain backdrop. On the busy streets of Venice, this was not easy to find. But by adopting a low-camera angle, I was able to frame the couple against the blue winter sky.
35–70mm, 1/125sec, f/8

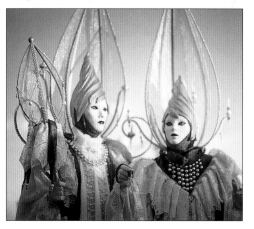

▶ **White wash**
Subjects that are predominantly white create a problem for the built-in camera meter. They tend to appear darker than expected in your pictures, unless you take corrective measures. To achieve a contrast in lighting, make sure that there are no highlights or shadows that will affect the calculations of the meter.
35–70mm, 1/125sec, f/4

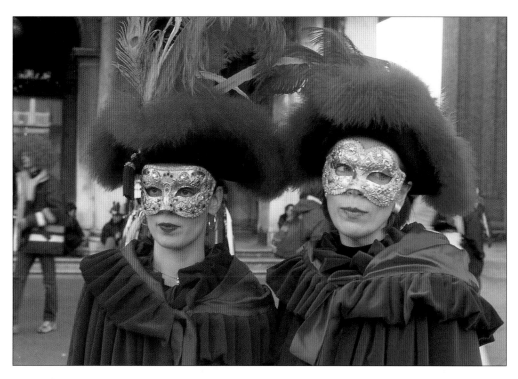

▲ Creating contrast
Creating a mood often depends on lighting and background In order to concentrate on the subject, use a wide aperture that throws the background into soft focus. In a crowd, you can isolate your subject by altering the camera angle. In this photograph, by kneeling down and looking up at the masked face, the figure has become framed against the light-coloured sky, creating a dramatic contrast. 35–70mm, 1/250sec, f/5.6.

ALBUM PICTURES

The appeal of photography is that it is accessible: you need no special skills, no period of training and, especially with modern fully automatic 35mm compacts and SLRs, you are virtually guaranteed of achieving a reasonable result. With a little bit of thought, however, your pictures, even if intended only for the family album, can have more impact and a far wider appeal.

Basic rules concerning framing the head correctly, avoiding unflattering facial shadows, separating your subject from the background, using simple studio lights as well as daylight and, perhaps most important of all, drawing your subject out of him or herself, are not difficult to learn and will, after a short period, become second nature.

As you can see from the selection of shots here, all of which could be described as album pictures, composition and technique do not need obviously to intrude.

▲ Facial contortions
People often pull faces. Some do it to show off, others because they are nervous, and sometimes it even helps them relax. 135mm, 1/60sec, f/4

► Children
Location shots tend to work best with young children, since the studio environment can be a little overpowering. Direct sunlight indoors does tend to be contrasty. 85mm, 1/60 sec, f/8

▼ Plain backdrop
Even family snaps can benefit from using a white backdrop and balanced lighting to get a better result. 85mm, 1/60sec, f/8

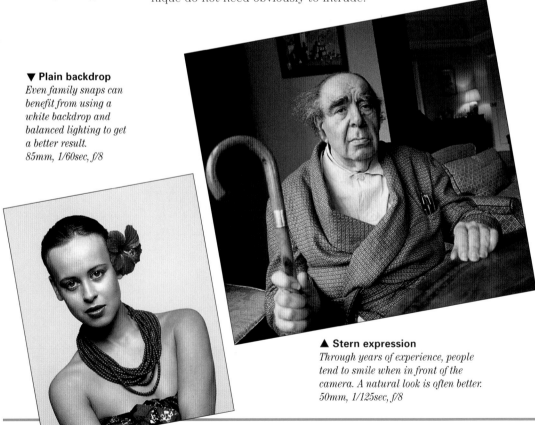

▲ Stern expression
Through years of experience, people tend to smile when in front of the camera. A natural look is often better. 50mm, 1/125sec, f/8

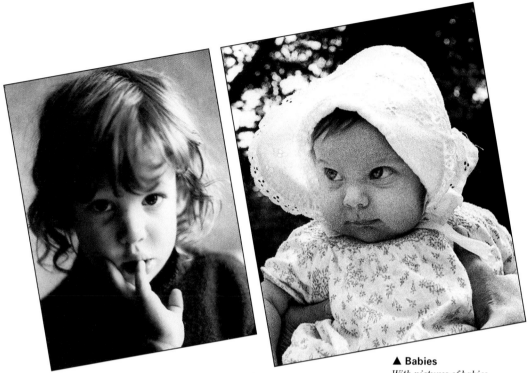

▲ Babies
With pictures of babies, you need to get down to their level or raise them up to yours.
50mm, 1/60sec, f/4

◀ ▲ Simple home set-up
With just one light and an umbrella you can achieve very professional results (left). To create a more even, rounded scheme, use reflectors either side of the subject, as shown in the diagram above.
120mm, 1/125sec, f/8

BUILDING A PORTFOLIO

If you are keen to develop as a photographer and to put together a portfolio of portraits that show a range of approaches and styles, you need to be flexible not only in respect of the techniques involved but also in how you perceive your work. Much to do with photography can be automated – the exposure, focusing, and so on. What cannot be automated, however, is the ability to present your subjects in an original or revealing way; this comes from having a basic understanding of people and how to relate to them.

When on assignment on location in somebody's home, spend as much time as possible beforehand speaking to them. Find out their likes and dislikes, and soak up the atmosphere before starting work.

▼ **Shrinking horizons**
It is an unfortunate fact of growing old that with decreased mobility your horizons tend to shrink. This is especially true if, as with this elderly lady in the photograph below, you are confined to bed. For her, the tangible world was to be found within the four walls of her sitting room, which now also served as a bedroom. On the walls, mantelpiece, tables and shelves stood the
cluttered mementos of her younger days – a fascinating collection of glass, souvenir china, family photographs and lovingly-tended plants. I wanted this photograph to reflect the feeling of looking in on a window on the past and to include the whole room, and decided to shoot from outside and use the lace-edged curtains as a type of vignette.
80mm, 1/60sec, f/16

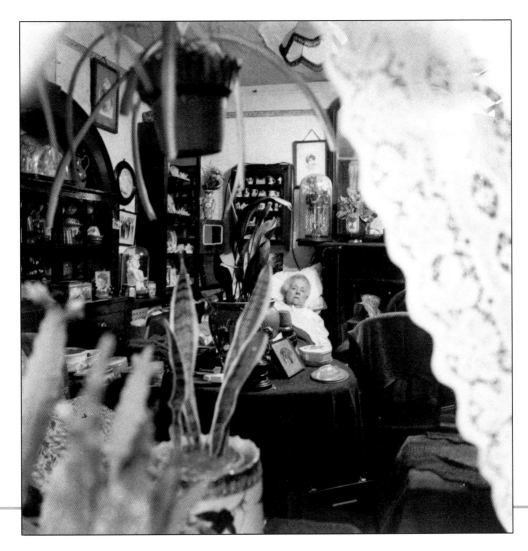

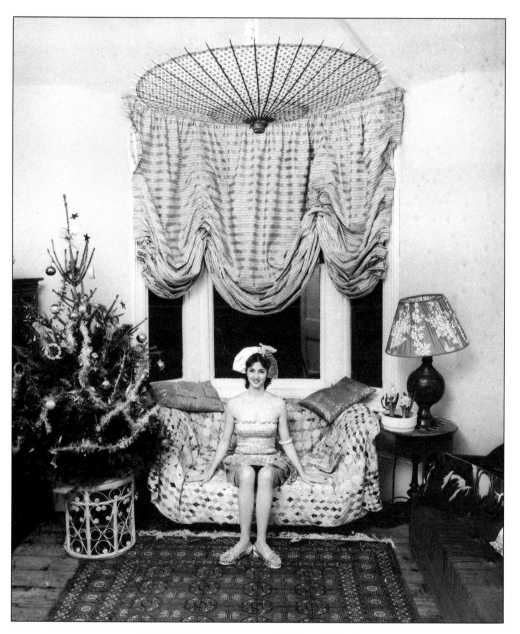

▲ **Bright future**
Contrasting with the
picture opposite, this
study of the writer and
historian Marina
Warner expresses the
lighter side of character.
In terms of visual
interest the room offered
tremendous scope,
with plenty of visual
variety supplied by the
furnishings and
Christmas tree – as well
as her hat, shoes and
clothes. I therefore
framed the shot to
include all the elements.
28mm, 1/125sec, f/11

CREATING A FOCAL POINT

Most photographers, especially those who take a lot of studio pictures, often feel the need to introduce an artificial focal point into their compositions. Even a simple prop, such as a hat or a bunch of flowers, can help to lift a photograph out of the ordinary. In particular, such a prop can be used to add colour or shape to the picture.

Bearing in mind that the object of the session is to produce a portrait, you need to ensure that your focal point does not dominate. Rather, it should initially attract attention to the picture by providing the setting, and then invite the viewer to look carefully at the main subject.

▲ Floral arrangement
A great deal of time went into creating and lighting this floral arrangement. To ensure that the bouquet was evenly lit I used two diffused floods, one at each side of the camera.
50mm, 1/125sec, f/5.6

▼ Changing the emphasis
I wanted to introduce a less-formal focal point to this portrait. A simple ploy was to add a few twigs to her hat.
85mm, x-sync, f/8

◄ Hair accent
Here, I used dead leaves and moss to provide a contrast in texture with the silky, flowing hair.
85mm, 1/30sec, f/4

▲ Framing with props
A veil of ivy creates a window frame around the model, inviting viewers to look in. I shot this picture with tungsten studio lighting and tungsten-balanced transparency film.
120mm, 1/60sec, f/11

◄ Central focus
The focal points in this picture are the woman and the vanishing point suggested by the converging lines of the patterned floor. The perspective of the receding lines gives a sense of depth. The centrally-placed figure balances the scene and gives a feeling of space and luxury.
28mm, 1/30sec, f/16

MONTAGE

Montage is a general term used to cover a number of different methods of physically combining portions of various prints. The technique can involve black-and-white prints, colour prints or a mixture of the two. Such tricks are now easily performed using digital manipulation programs on a computer, but montage can be fun to have a go at using traditional cut-and-paste methods.

It helps if you have at least a vague notion of how the finished product should look before starting. Look through your collection of existing prints and decide whether any are suitable. Perhaps you could use the sky from one print, a person from another, and some interior feature from a third.

The more elements you combine from different originals, the more abstract the finished montage is likely to be. You could, for example, use most of the elements of a base print and just stick a person on top to make an odd juxtaposition; or you could opt for a totally abstract image.

The first step with any style of montage is to cut out carefully the portions of images you want to use with a scalpel. Where you place one image on top of another, the extra thickness of paper will reveal the join. If you do not want this to show, you will need to remove as much of the excess paper as possible. To do this, turn the surface print over and sandpaper away the edges of the paper until you almost reach the emulsion layer, and then blacken the exposed edges to hide the joins. With resincoated printing papers, you may be able to peel back the emulsion layer itself and then cut away the base.

For a particularly realistic effect, you can combine montage with airbrushing – in order to cover joins, and to create shadows. Airbrush cans of compressed air and suitable dyes are can be bought, but you will have to mix these to get the precise colour or tone you need.

◀ The eyes have it

When looking at people we always look at the eyes first. Here, the multiple eyes have an immediate, and disturbing, impact. All I needed was five identical prints. Four prints were cut off just above the eyes, using a metal rule and scalpel. These were then glued onto the fifth, uncut, print.

▶ Panoramic view

This 'joiner' technique is often used when shooting wide panoramas – you move the camera across the scene taking a series of photographs. Afterwards the prints are aligned and mounted together to give a broad sweep that couldn't be achieved with a single shot. Here, a wide-angle lens and a low camera angle was used to take a series of photographs of the girl. The viewpoint has changed slightly for each picture, and this effect is then exaggerated by mounting the shots in a disjointed fashion.

◀ Various sources

If you want to include images of people or places that you haven't photographed in your montages, you could use other sources – such as books, magazines and so on. Remember, though, that you must obtain permission for the use of all copyrighted material. The images can be combined by simple cut and paste, or by using computer manipulation.

POST-CAMERA TECHNIQUES

For many photographers, the image produced by the camera is regarded as being merely the starting point in the creative process. Black-and-white photographers in particular are often inclined to have their own film-processing and print-making facilities at home: all that is needed for this is a small, light-tight space and a basic amount of equipment.

A home black-and-white darkroom is likely to be a more attractive proposition not only because equipment needs are minimal but also because black-and-white chemicals and printing papers are more tolerant of slight changes in processing times and temperatures. With colour, as well as very precise time and temperature control, you also have the additional problem of judging, testing and setting a series of filters in order to produce successful prints. Colour analyzers are readily available to work this out for you, but these add to the cost, making the use of a laboratory more likely.

SPECIAL EFFECTS

With a black-and-white darkroom set-up, the range of special effects you can achieve is wide, including the selection presented here. The ghost-like negative print below and the two different types of Sabattier effect (also, incorrectly, known as solarization) at the bottom of the page require no special equipment at all.

The print opposite, although not in any way difficult to produce, does require a special screen, which you can either buy or make yourself from any suitably patterned translucent material.

◀ Negative print
For this result, place a transparency in the enlarger and project it on to ordinary printing paper. You can also contact-print a photograph to make a negative print by placing the print face down on a sheet of printing paper and projecting light through the back of it. Lay a piece of clean glass over the top to ensure that the print and paper are in close contact.

▶ Sabattier effect
For the type of effect shown right, allow the print to develop for about half its normal time (approximately 1 1/2 min) and then flash the white room lights on for about 1sec and continue development. For the picture far right, place a piece of black cardboard over areas of the print you do not want affected by the room light.

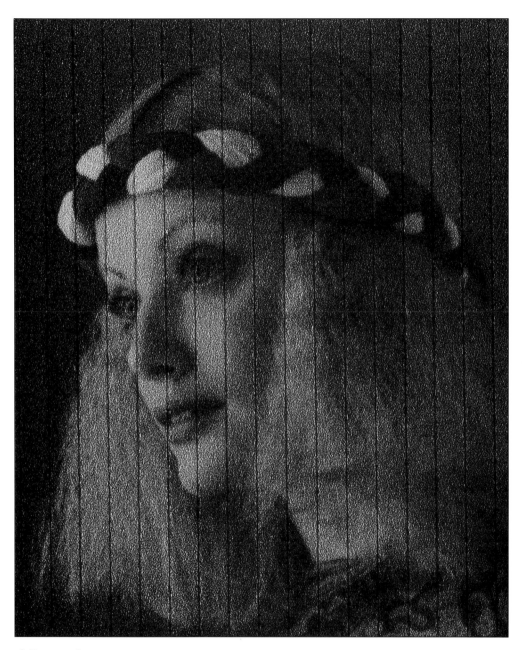

▲ Screen prints
Printing ordinary negatives through a textured screen is a very easy and eye-catching technique. For this print, a piece of clean frosted and etched glass was laid over the printing paper and the negative projected down from the enlarger as normal. The type of screen effect you get in the end depends entirely on the material you use. Also available are commercially produced screens giving a wide range of patterns. A variation on this is to place the screen material with the negative.

PAPER GRADES

Photographers working in black and white have a level of control over image contrast that is not available to users of colour – that of paper grade. If you have a darkroom at home, you can choose printing paper from approximately six different contrast grades, ranging usually from 0 to 5, in either single-weight or double-weight fibre-based types or in medium-weight resin-coated stock.

Also available is a variety of paper finishes, such as stipple texture, matt or glossy. If you have your negatives printed at a commercial laboratory, you should still be able to specify the type of paper you want used.

WHICH PAPER?

Briefly, in terms of image contrast only, fibre-based papers tend to produce a more solid black and a cleaner white than resin-coated, though resin-coated papers are quicker to process (especially at the washing stage,

since processing chemicals cannot penetrate the paper itself) and easier to dry.

In terms of contrast, grade 0 produces the maximum number of half tones between pure white and solid black and, therefore, the least contrasty image. If you have a contrasty image, however, then grades 0 or 1 should produce the most normal-looking print. Grades 2 and 3 are meant for use with normal-density negatives, and grades 4 and 5 are designed to produce normal-looking prints from low-contrast negatives.

To avoid having to keep a stock of different-grade papers, you can, instead, use a multigrade paper. This paper is made so that its contrast-recording ability can be altered depending on the type of filter positioned under the enlarger lens. An added advantage of this variable-contrast paper is that you can print different areas within the same picture at different grades.

▶ **Reducing film contrast**
This picture, showing the composer Igor Stravinsky during a rehearsal session, was taken in dim lighting conditions without flash. To compensate for this I under-exposed the film one stop and increased development time accordingly. The resulting negative was then printed on grade 1 paper in order to correct, as far as possible, the overly harsh contrast typical of film that has been pushed in this way.

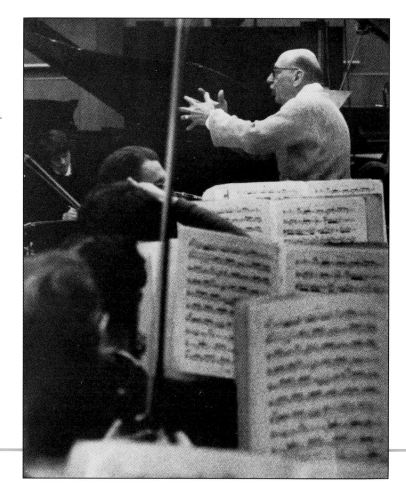

▶ **Using medium-contrast paper**
The negative for this picture, showing the author Agatha Christie, was of normal density, with contrast neither too harsh nor too soft. With a negative such as this, medium-contrast printing paper, usually designated as grade 2 or 3 by the manufacturers, will produce the best type of print, with a solid black, clean whites, and a wide range of greys in between.

◀ **Using soft-grade paper**
In this version of the print the same negative was used. The only difference is that it was printed on grade 0 paper. Even allowing for the fact that some subtlety is lost during the book-production process, it is possible to see that a normal-contrast negative starts to take on a 'muddy' appearance on soft paper, with the whites, especially, looking a little grey.

▶ **Using hard-grade paper**
Again, the same normal-contrast negative was used, but this time it was printed on grade 5 printing paper. The differences are now startling. Gone, almost completely, are the gradations of grey, and the image largely consists of blocks of black and areas of white. If this paper had been used with a very soft-contrast negative, though, the result would have been more like the version at the top of the page.

GLOSSARY

Air brushing A technique in which dye or pigment is sprayed with compressed air over an area of a print. Air brushing can be used to remove unwanted parts of a scene, to change its colour of texture, or to hide joins where prints overlap, as in *montage*.

Ambient light The light that is normally available. Outdoors, this would be light from the sun, while indoors the term describes ordinary domestic lighting, as opposed to photographic lighting in a studio.

Angle of view The outer limits of the image area seen by a lens. Wide-angle lenses have a wider angle of view than telephoto lenses. Also sometimes known as the convening power of a lens.

Aperture The opening in a lens through which light is admitted. On all but the simplest cameras, the size of the opening can be varied, either automatically by the camera or manually by the photographer via the *aperture ring*.

Aperture priority A type of camera exposure system where the photographer determines the *aperture* and the camera sets the *shutter speed*.

Aperture ring The control ring located on the barrel of most lenses that can be turned by the photographer to control the size of the *aperture*. The aperture ring is calibrated in a series of *f-numbers*.

Artificial light film Colour film designed to be exposed under tungsten light with a *colour temperature* of usually 3200K. Under this type of lighting, colours will appear normal, if exposed in daylight, however, a blue *colour cast* will result unless an appropriately coloured correction filter is used over the camera lens.

ASA A number classification devised by the American Standards Association to represent the sensitivity of film to light. Now almost universally replaced by the *ISO* classification, which uses identical numbers.

Available light See *Ambient light*.

Backlighting Light coming from behind the subject and toward the camera. Unless a backlight-compensation-button is provided, automatic cameras will tend to *underexpose* a main subject lit this way.

Barn doors A lighting accessory, comprising usually of four metal flaps, that fits round the lighting head of a *floodlight* or *spotlight* and is used to control the spread of the light beam.

Bounced light Light, usually from a flashgun or photographic light, that is directed at a surface, such as a wall, ceiling or special reflective umbrella, and is reflected on to the subject. This arrangement gives a soft, diffused effect and helps to avoid unattractive shadows.

Bracketing A series of different exposures of the same scene and viewpoint taken in order to obtain the best result. Usually, the difference in exposure between frames in the series is one-half of a *stop* above and below the estimated exposure level.

B-setting A *shutter* setting that holds the shutter open for as long as the release button is depressed, its purpose is to provide exposure times longer than those allowed for on the camera controls.

Catadioptric lens A telephoto lens that uses a combination of lens elements and mirrors to increase the length of travel of light within the lens and so produce a long focal length in a short barrel. Also known as a mirror lens.

Close-up A photograph in which the subject's head occupies most of the frame.

Colour cast An overall bias toward one particular colour in a colour print or slide. A blue colour cast is noticeable when *artificial light film* is exposed in daylight.

Colour saturation The purity or apparent strength of a colour. With colour film, colour saturation can be strengthened by slight *underexposure*, with an associated loss of some shadow detail.

Colour temperature A method of describing the colour content of different light sources, usually expressed in degrees Kelvin (K). Red light, at approximately 1800K, has a lower colour temperature than blue light, approximately 6000K. Many

studio light sources have a colour temperature of 3200K, while sunlight has a value of between 4500 and 5000K.

Compact camera A small, highly automated 35 mm camera, usually featuring automatic exposure, autofocus, and automatic film transport.

Contre-jour An alternative name for *backlighting*.

Converter lens An accessory that fits between the camera body and lens and doubles (x2) or trebles (x3) the focal length of the lens. With this accessory there is always some loss of lens speed and of *resolving power*.

Covering power See *Angle of view*.

Darkroom A light-tight, well-ventilated room used for developing film and making prints.

Dedicated flash A flashgun designed for use with a specific camera or range of cameras. It connects to the camera's circuitry and can, for example, alter the camera *shutter* to ensure a correct *exposure*.

Depth of field The zone of acceptably sharp focus surrounding the point of true focus. The size of this zone extends approximately one-third in front of and two-thirds behind the point of focus and varies according to the *aperture* set, the focal length of the lens, and the distance of the subject from the lens. Basically, the smaller the aperture, the shorter the focal length, and the more distant the subject, the greater the depth of field.

Diffuser Any translucent material held over a light source or, less usually, the camera lens, that can scatter light and produce a softer lighting effect or image.

Emulsion The light-sensitive coating on film or printing paper where the image forms.

Exposure The product of the intensity of light reaching the film (controlled by the *aperture*) and the length of time the light is allowed to act (controlled by the *shutter*).

Exposure latitude The degree of *over-exposure* or *under-exposure* an emulsion will tolerate and still produce an acceptable image.

Fast film Film that is highly sensitive to light. Such films have an *ISO* rating of 400 or more.

Fast lens A lens with a wide maximum *aperture*, denoted by a low *f-number*.

Fill-in light A secondary artificial light source, usually used to lessen contrast and lighten or remove shadows.

Film plane The position in a camera where the film lies. This is also the plane where light from the lens is brought into focus.

Filter factor The number engraved on a filter mount by which *exposure* must be increased to compensate for light removed by the filter.

Fisheye lens An extreme wide-angle lens, with an *angle of view* exceeding 180°. This type of lens produces highly distorted images, with distinct curving of vertical and horizontal lines. *Depth of field* is, however, almost infinite with this type of lens, and so focusing is very often unnecessary.

Flash synchronization A system of ensuring that the flash fires only when the *shutter* is fully open. This synchronization speed is often marked in red on the *shutter speed* dial.

Floodlight A studio tungsten light source with a dish-shaped reflector producing a wide beam of light.

f-numbers A series of numbers found on the aperture control ring of a lens indicating the size of the *aperture*. Moving the control ring to the next lowest number doubles the size of the aperture and reduces *depth of field*. Also known as f-stops.

Focal plane The position in a camera where light from the lens is brought into focus. The focal plane and the *film plane* coincide.

Focal plane shutter A mechanism consisting of two horizontally or vertically travelling 'blinds' placed just in front of the *focal plane*. The gap between the two blinds is determined by the *shutter speed*.

Grade A system of numbers describing the contrast-recording ability of black and white printing papers. Grade 0 records the greatest number of tones; grade 5 the least.

Graduated filter A coloured filter that gradually reduces in density towards the centre, leaving the other half clear.

Graininess The visual appearance of the black metallic silver grains that make up, after development, the photographic image. Pronounced graininess has a detrimental effect on the detail – recording ability of the photographic *emulsion*. Graininess is more obvious in *fast film*.

Guide number A number denoting the power of an artificial light source such as flash. To determine the *f-number* to set, divide the subject distance by the guide number. The figure applies to *ISO* 100 film and to subject distances measured in feet or metres.

High key A photograph or slide in which lighter, paler tones predominate.

Highlight The lightest part of a positive image. On a negative, a highlight appears as the area of greatest density.

Hot-shoe An accessory found on the top of nearly all modern cameras that do not have built-in flash. An electrical contact on the bottom of the shoe fires the flash and forms part of the *flash synchronization* circuit.

Hue The name of a colour.

Incident light The light falling on an object or scene. An incident-light exposure reading measures this light, as opposed to that reflected back by it.

Intersection of thirds Also known as the rule of thirds, a method of image composition in which the frame is divided into thirds, both horizontally and vertically, by imaginary lines. Any object positioned at the intersection of any of these lines is thought to have additional emphasis within the composition.

ISO A number classification devised by the International Standards Organization to represent the sensitivity of film to light. It has now almost universally replaced the *ASA* system, although it uses identical numbers.

Kelvin (K) A unit of temperature measurement used to describe the colour content of a light source. See also *Colour temperature*.

Key light The principal light source used to light the subject in a studio set-up.

Kilowatt A measurement of electrical power (and, thus, of light output) signifying 1000 watts.

Large-format camera A camera, usually used in the studio, that takes individual pieces of cut film, as opposed to 35 mm cassettes or rollfilm.

Latitude See *Exposure latitude*.

LED (light-emitting diode) A visual display system for indicating camera functions, such as shutter speed and aperture, seen either in the camera *viewfinder* or on a panel on the top plate of the camera.

Lens speed See *Fast lens*.

Low key A photograph or slide in which dark, sombre tones predominate.

Magazine A light-tight container used for bulk lengths of film. Also used to describe the type of removable film holder found on most medium format cameras.

Mirror lens See *Catadioptric lens*.

Mode An exposure operating programme (usually one of several) available on automated cameras.

Modelling light A light used to create shadow and light and a more natural, three-dimensional effect. Also a low-output, continuous light source built into the lighting head of studio flash units. It does not affect exposure but allows the photographer to preview the pattern of light and shade that will be created when the flash fires.

Montage A composite picture made by physically combining parts of prints to create a new composition.

Neutral density filter A grey filter used over the camera lens to reduce the amount of light reaching the film without affecting the colour balance of the photograph or slide.

Opening up Increasing the size of the *aperture* by selecting a lower *f-number* in order to allow more light to reach the film.

Overexposure The result of exposing a light-sensitive *emulsion*, either film or paper, to too bright a light source or allowing that light source to act on the emulsion for too long.

Panning Swinging the camera to track a moving subject while the *shutter* is open. This produces a relatively sharp image of the subject against a blurred background.

Parallax error The difference in viewpoint between the scene recorded by light entering the lens and that seen through a direct-vision *view-finder*. This problem does not arise with an *SLR*.

Pentaprism A five-sided prism found on the top plate of nearly all *SLR* camera. Its internal reflective surfaces produce a correctly orientated image in the viewfinder. Without a pentaprism, the image seen would be reversed left to right.

Portrait lens A short telephoto lens with a focal length about twice that of a standard lens, and considered ideal for *close-ups* and head-and-shoulder shots.

Pushing Under-exposing film to gain speed in low-light conditions and then compensating by increasing development time. There is an a ssociated increase in image contrast with this technique. Also known as uprating.

Recycling time The time taken for an electronic flash to recharge, ready to fire again.

Reflected light reading A measurement of the amount of light being reflected by the subject. Used by all *TTL systems*.

Resolving power The ability of a lens to produce fine subject detail.

Reversal film Any film producing a direct positive image that is viewed by transmitted light. Also known as transparency or slide film.

Sabattier effect A part positive, part negative image formed by briefly exposing printing paper to white light during the development process. Development then continues normally.

Sensitivity The degree by which a photographic *emulsion* is affected by exposure to a light source.

Shutter Any mechanical arrangement that deter-mines the length of time light is allowed to act on the film in a camera. See also *Focal plane shutter*.

Shutter priority A type of camera exposure system where the photographer determines the *shutter speed* and the camera sets the *aperture*.

Shutter speed The length of time the *shutter* remains open, allowing light to act on the film.

Slave unit A device that reacts to light from the main light unit connected to the camera and triggers an additional electronic flash. Allows multi-flash set-ups to be used without any connecting cables.

SLR (single lens reflex) A camera system that uses a 45° mirror situated behind the lens to direct light entering the lens to a *viewfinder*. Just before exposure, the mirror swings out of the way, the *shutter* opens, and the film is exposed. This arrangement means that the image in the viewfinder always exactly corresponds to that recorded by the film. At the time of actual exposure, though, the viewfinder goes blank.

Spotlight A studio tungsten light source that uses a reflector and lens to produce a narrow and focusable beam of light.

Stop Another name for *aperture*.

Stopping down Decreasing the size of the *aperture* by selecting a higher *f-number* in order to restrict the amount of light reaching the film.

Tonal range The shades of grey between pure white and solid black, or between the lightest and darkest areas in a particular image.

Transparency See *Reversal film*.

TTL (through the lens) An exposure system that uses sensors inside the camera body to measure light entering through the lens. This system is used in nearly all *SLR* cameras.

Tungsten light film Colour film that is designed to be exposed to studio lights of about 3200K. If exposed under daylight conditions, this type of film will produce a distinct blue colour cast unless a correction filter is used over the camera lens. See also *Colour temperature*.

Underexposure The result of exposing a light-sensitive *emulsion*, either film or paper, to an insufficiently strong light source, or allowing that light source to act on the emulsion for too short a period.

Uprating See *Pushing*.

Viewfinder An optical sighting device on a camera, used as an aid to composition and for focusing. The viewfinders of many modern cameras also contain all exposure information.

INDEX

JAN 4 2001

ACKNOWLEDGEMENTS

Associate Writer: Chris George
Editorial Director: Sarah Hoggett
Editor: Katie Hardwicke
Designer: Claire Graham
Photographer's Assistant: Jenny Mackintosh

Author's Acknowledgements
Château de Bagnolf, English Heritage, Guernsey Tourist Board,
The Jordanian Ministry of Tourism and Antiquities.